Byron Hot Springs

IMAGES of America

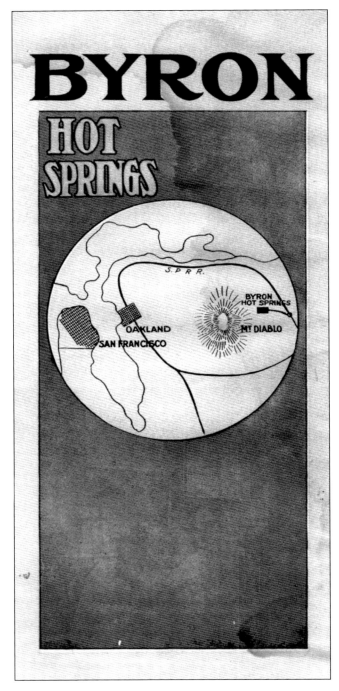

For over 150 years, people have found Byron Hot Springs, California, to be their destination. They came on horseback and by wagon, railroad, and automobile. Initially, they came for the healthful benefits of the waters and relief from bodily woes. Socialites later came for fun and recreation. Byron is far enough from San Francisco to be isolated but not remote. The town is only 65 miles, or two hours, from San Francisco. San Jose is 40 miles or close to 60 minutes away. Transportation time is the same today with modern traffic as it was in 1915 by railroad and ferry across the bay.

ON THE COVER: Guests lounge on the lawn at the Byron Hot Springs Hotel during the 1930s at the "Carlsbad of America." Vintage postcard images provided compliments of a private collector.

Byron Hot Springs

IMAGES of America

Carol A. Jensen
East Contra Costa Historical Society

Copyright © 2006 by Carol A. Jensen
ISBN 0-7385-4700-X

Published by Arcadia Publishing
Charleston SC, Chicago IL, Portsmouth NH, San Francisco CA

Printed in the United States of America

Library of Congress Catalog Card Number: 2006933246

For all general information contact Arcadia Publishing at:
Telephone 843-853-2070
Fax 843-853-0044
E-mail sales@arcadiapublishing.com
For customer service and orders:
Toll-Free 1-888-313-2665

Visit us on the Internet at www.arcadiapublishing.com

Grandfather Niels Jensen sent his wife and children a postcard from Byron Hot Springs in the 1920s. Mom saved it and gave it to me. I have it still.

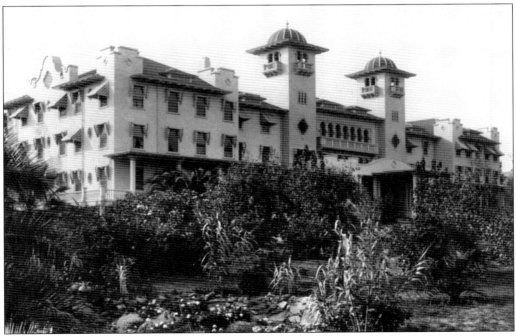

The Moorish-style Second Hotel, constructed in 1902, is typical of other buildings designed by Reid Brothers, Architects. James Reid was the preferred architect of John D. Spreckels and designed both his Market Street "Call" Building and the Nob Hill Spreckels mansion. At Byron, Reid created a romantic and exotic theme for his friend, Lewis Mead. The impression is striking. Reid used this theme again most notably in motion picture houses.

Contents

Acknowledgements		6
Introduction		7
1.	The Early Resort—First Hotel	9
2.	Health and "Taking the Cure"	33
3.	The Second Hotel	51
4.	The Third Hotel	79
5.	Society at Play	89
6.	"Camp Tracy"—Interrogation Center	103
7.	The Resort Sleeps	115
The Family Tree		125
Time Line		126
Bibliography		127

ACKNOWLEDGMENTS

This book would not have been possible without Kathy Leighton and the resource room of the East Contra Costa Historical Society. I am indebted to the following institutions and their staff members: the California Historical Society; the Society of California Pioneers; the National Archives; the California State Library; the Bancroft Library; the University of California, Berkeley and the Medical School Rare Book Room of the University of California, San Francisco; the Argonaut Book Shop; the Antiquarian Booksellers' Association of America; the Oakland Museum; the Alameda County Public Library and Oakland History Room; the San Francisco Public Library, San Francisco History Room; the Contra Costa County Public Library; and the Brentwood Public Library.

Warm appreciation to the following local, community, and regional historical societies: the Saline Area Historical Society in Saline, Michigan, the John Marsh Historic Trust, Inc., the Ascension Orthodox Church Historical Committee in Oakland, the St. Basil Greek Orthodox Church Historical Committee in Stockton, the Martinez Historical Society, the Contra Costa County Historical Society, and the *Tracy Press* and its editor, Sam Mathews. Only from these sources are anecdotes found to personalize history. Thanks also to those who have shared their family histories stories, photographs, and collectables, most notably Mary Mousalimas.

Past owners and residents of Byron Hot Springs have been most kind in sharing their experiences. My gratitude to ephemera dealers and collectors Ken Gaeta, Ken and Dorothy Harrison, Ed Herny, Ken Pragg, Jeff Carr, and Bill Maxwell, who scanned their collections for inclusion in this book. Thanks to Robert Chandler, the historian of Wells Fargo Bank, for his persistent encouragement, and John Poultney, Arcadia Publishing editor, for his interest in the growing communities in eastern Contra Costa County. The aid of the irreplaceable Robert D. Haines Jr. cannot be overstated. Thanks to Kathleen and William Mero and Bob Gromm for their help and mapmaker Marcy Protteau for her final proofing.

Please contact the author at the e-mail address historian@byronhotsprings.com if you can contribute to Byron Hot Springs history with an oral history, family documents, letters, or ephemera.

INTRODUCTION

The Byron Hot Springs Resort boasts a rich history of visitors and uses. Native Americans knew the salt springs from time immemorial; members of the Bolbones tribe were camping in the area as the first Anglo Europeans found their way into California. Prior to 1760, fur traders and "Mountain Men" visited the area. Beginning in 1773, early Spanish explorers discovered the springs in their recognizance of California. The resort, founded in 1865, predates the town of Byron by 13 years. The Southern Pacific Railroad regularly stopped seven times a day at the Byron Hot Springs depot to discharge freight and visitors. Many people do not know the historic resort still exists behind locked gates, as they travel by car to the Byron Airport along Byron Hot Springs Road.

The pools of hot, sulfurous, salty water are a natural attraction to man and animal alike. Surface water and natural salt licks attract deer, bears, elk, and their natural predator, the mountain lion. The natural temperature of the waters ranges from 80 to 100 degrees. It is easy to imagine the pleasure of a warm water soak during the winter weeks of cold delta tule fog.

Word of the pools led to informal bathing and physical improvements of the site. Donner Party survivors settled here, and their descendents claim that the origin of the name "Byron" stems from a Californio's report of a "bruin" or "bear-on" or "bar' en" at the hot pools in midwinter. After California joined the union in 1850, and the easy wealth from placer gold mining was largely exploited, original Californios like John Marsh were desperate to secure their extensive Mexican land holdings under U.S. real estate law. Marsh was partially successful in confirming his land grant, but the court set his property line west of the salt springs, allowing others to claim the springs as their own.

John Risdon of Saline, Michigan, was just such a man to tap the commercial resources of the Byron salt springs. Risdon came to San Francisco to establish himself in iron manufacturing. John and his brother Orange Jr., together with their partners William Ware and James Coffey, were involved in a succession of iron and boiler works. The most notable is the Risdon Iron and Locomotive Works in San Francisco. Salt was a key ingredient to iron manufacturing. The Risdon Iron Works was exceedingly successful and lucrative, holding patents for the first river mining dredge, producing iron pipe for transporting water to San Francisco from the Crystal Springs Reservoir and iron girders of the San Francisco Ferry Building, and providing the iron infrastructure for the burgeoning Virginia City Comstock mines.

John and Orange's father, Orange Risdon Sr., founded the City of Saline, Michigan, and named it for the region's mineral salt resources, so it was no coincidence that John Risdon and his brother Orange Jr. sought commercial salt manufacturing opportunities in California. They surveyed the hot springs property, improved it by constructing four small buildings, and filed a land patent for 160 acres (four parcels of 40 acres each) with the salt springs in the center.

Orange Jr., a single man, filed the appropriate forms and attestations with the United States Land Office in Martinez using a military land warrant—a common method of paying military volunteers of the time. Land warrants traded easily and were often sold by recipients at a significant discount. Orange Jr. used it as the basis of the land patent application for the 160 acres in his name only, unknown to his business partners. Upon this fact does the following tale rest.

The Risdons incorporated the Saline Salt Manufacturing and Mining Company in 1863 to exploit the salt springs, but manufacturing and transporting salt from the hot springs was not economically practical given the area's remoteness. No railroad serviced Byron at the time and overland hauling was prohibitively expensive. The salt idea was abandoned, and the property continued as an informal spa and watering hole. People camped at the site, bathed in the pools, and drank the waters for their various healthful and cathartic effects.

In October 1865, Risdon's 18-year-old nephew, Lewis Risdon Mead, arrived in San Francisco. At once, he became associated with the family ironworks and began developing the 160-acre salt springs property along with his uncle. The springs were becoming increasing popular with campers "squatting," but losing property to squatters was a real threat to land ownership. Orange Jr. and Lewis Mead set to work to rectify the problem.

The actual mineral springs are named according to their content or the purpose for which they are used. The "salt springs" were heavily laden with magnesium, the "liver and kidney" spring's waters were drunk under the impression that these two organs greatly benefited or were cleansed by their consumption, and the "white sulfur" springs contained a high percentage of sulfur and were housed in a separate building. Sitting in mineral waters was also popular as hydropathy and hydrotherapy were considered medical sciences at the time. Eventually a wooden swimming pool, 44 feet long, 20 feet wide, and 4 to 6 feet in depth, was constructed and housed in a separate building. It was named the Gas Plunge because a natural gas constantly bubbled through the water.

Lewis became fast friends with architect James W. Reid, who subsequently designed the hotels at the springs and would be a constant visitor and intimate. Visitation increased and two annexes of rooms were added to the original four cottages.

A dramatic change happened in 1866 when Orange Jr. died unexpectedly without marrying or having heirs. His estate, consisting of cash and the salt springs real estate, reverted to his father in Michigan, and Lewis Mead, Orange's nephew, was named administrator. He proceeded with probate, bought the salt springs from his grandfather, settled the estate, and applied to confirm the sale, believing clear title was now his.

However, John Risdon and his associates alleged an ownership right in the property, saying that Orange Jr. had acted as their agent as bookkeeper for a Risdon subsidiary. All costs for building construction, land surveying, and land filing were incurred by John Risdon, who claimed Orange held only a part interest and was acting as agent and trustee for the principles of Ware, Risdon, and Coffey. Securing capital without a quiet, uncontested title to the property was impossible, so Mead sued.

After four years of countersuits, depositions, out-of-court proposals, and intra-family negotiations, the court confirmed Mead's fee simple, absolute title in the property in 1885. With a $10,000 loan, he immediately began improvements and marketing efforts to bring more and more San Franciscans to the resort. Playing up his business and social connections in San Francisco, he rechristened the resort Mead's Hot Springs. Printed advertisements in the *Overland Monthly*, the *Wasp*, the *Sunset Magazine*, and *Harper's Magazine*, next to Hotel Del Monte advertisements when possible, solidified national exposure. Byron Hot Springs was fast becoming the "Most Famous Health Resort in the West!"

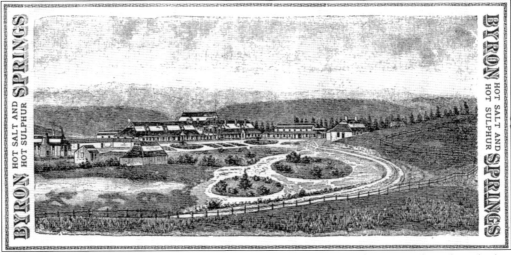

This early engraving shows the hotel at Byron Springs and surrounding grounds as described in the resorts earliest brochure, c. 1878. The 10-panel advertisement touts Byron Springs as "pre-eminently the natural sanitarium of California and the Pacific Coast." Accommodations varied from $12 to $21 per week with no extra charge for the curative waters.

One
THE EARLY RESORT—
FIRST HOTEL

Lewis Mead, owner, leased management of the hot springs property to H. C. and Amanda E. Gallagher in 1878. Amanda is credited with building bathhouses over several of the springs and establishing a stage line from the town of Byron. Once fee simple title was secured, Mead promptly borrowed $10,000 from the Hibernia Bank for improvements. Smaller buildings were remodeled and covered by one continuous roof, thereby creating the First Hotel. Mead built a residence, known later as the Mead Cottage, for his wife. The salt basin was filled with 10 to 12 feet of good earth upon which a beautiful semitropical garden was created with evergreen trees, palms, and flowers. A large square was fashioned in front of the hotel with a wide graveled drive divided into four sections by walks. Each section was beautifully landscaped and illuminated at night by gas lamps. By 1887, it was an oasis rising in the midst of an alkali desert. Popularity and profitability of the property increased measurably.

This First Hotel, a wooden structure, was built at a reported cost of $50,000 and was 300 feet long by 30 feet wide, with two wings of 50 feet by 100 feet each. The main floor housed guest rooms, the post office (established August 17, 1889), the hotel business offices, the dining room, and other public rooms. Albert Bettens, the manager, and his wife occupied a portion of the second floor, consisting of six rooms. The kitchen, pantry, and cold storage were all housed in one wing off the dining room. Directly over the main entrance was a tower-like structure that added a partial third floor and afforded views to the east and west. A large veranda extended the full length of the building.

Tragically, on July 25, 1901, fire destroyed the hotel, a cottage containing 20 rooms, the laundry, the gas plant, and the ice plant. The fire was discovered at about 1:00 p.m. while the guests were at lunch. The staff attempted to stop the fire but was helpless with the equipment at hand. The hotel staff took all 14 guests to safety with most of their baggage.

Early Spanish explorers found the springs early in their recognizance of California. A series of Spanish explorers visited the area beginning in 1772. Explorer Pedro Fages described the area in his journal. The following year, Juan Bautista de Anza made note of the salt springs, and Jose Joaquin Moraga visited the area in 1776.

Native Americans knew the springs from time immemorial. Members of the Bolbones tribe camped in the area as the first Anglo Europeans found their way into California. John Marsh, the first Anglo European to settle in the Central Valley, hired the local Native Americans in his cattle ranching. The Byron Springs provided the crucial component necessary for successful cattle ranching—a salt lick.

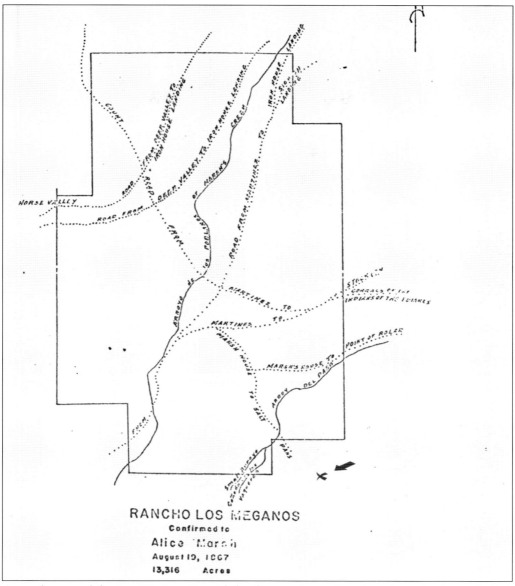

RANCHO LOS MEGANOS
Confirmed to
Alice Marsh
August 19, 1867
13,316 Acres

An early map of the Jose Noriega Spanish land grant shows the salt springs clearly marked. A subsequent map, pictured here, describes the land acquired by John Marsh from Noriega and indicates a well-labeled trail leading from the Marsh adobe to the salt pans. The location of a salt lick or salt mine would be an invaluable asset necessary for sustaining life, preserving meat, and manufacturing. Mountain men visited the salt pans prior to 1760. John C. Fremont and Kit Carson came close to the springs during their 1842 western exploration and survey as they traveled up the San Joaquin River by boat. Shrewd John Marsh recognized the value of this salt source and included it in his 50,000-acre Rancho Los Meganos land grant purchase as confirmed by Alcalde Jose Noriega and the Mexican government. Unfortunately, for Marsh, the Treaty of Guadalupe Hidalgo, ending the Mexican American War in 1848, would reduce his land ownership to approximately 36,000 acres and exclude the salt springs. By 1856, the land surrounding the salt springs was open for claim under United States property laws.

TERRITORY OF NEW MEXICO,
County of Valencia

On this 11 day of October A. D. 1860 personally appeared before me, the undersigned, a Justice of the Peace, in and for the county and Territory aforesaid, Estelan Mansanares aged years a resident of Valencia County New Mexico who being duly sworn according to law declares and says, that he is the identical Estelan Mansanares who was a Private in Capt. Juan Montoya's Company New Mex. Mtd. Vols. in the Military Service of the U.S. which Company was organized by Capt Juan Montoya at Sabinal & was enrolled and mustered for service by Hon. J. M. Sanches y Baca Probate Judge of the Southern District of New Mexico, in the month of April 1848, under and in conformity to an order or circular of the Military Commander U.S.A. Proclamation of the Civil Governor of New Mexico 846-738 & order N.22 3 March 1848, from Col. Newly, Comdg Military Dept of New Mexico authorizing the organization of Vol Companies, for the protection and defence of New Mexico. That he entered the said service, on or about the 15 day of April 1848 & served in said Company cooperating with the armed forces of the U.S. on a campaign against the Navajo Indians, Indian disturbances & Mex. War for the term of fourteen days, was engaged during said service in a battle with said Indians as will appear from the Rolls or list of said Compy & was honorably discharged from said service on cessation of hostilities

He makes this declaration for the purpose of obtaining the BOUNTY LAND, to which he may be entitled, under the Act of Congress of March 3d 1855, and May 14th 1856, and that he has never received Bounty Land under this, or any other previous Act of Congress, nor made any other previous application therefor, and hereby constitutes and appoints H. G. Hank Esq Washington D.C. his Attorney irrevocably, to prosecute his claim and to do all and every act and thing necessary in the premises. hereby ratifying and confirming all that his said Attorney may do in the premises.

Attest: Esteban + Mansanares
 his mark

Sworn to and subscribed before me, on the day and year first above named, and on the same day and year before me personally came Anastacio Arriego and Juan Montoya

Events along the New Mexico border changed the destiny of Byron Salt Springs. Pvt. Esteban Mansanares of Valencia County enlisted in Capt. Juan Montoya's Company of New Mexico Mountain Volunteers in April 1848 during the Mexican American War. The Mexican government enlisted the support of the Navajo Indians to harry citizens living along the border and pull regular U.S. Army troops away from main battle engagements. For 14 days of service, Mansanares, who was unable to write his own name, was paid, honorably discharged, and received a "bounty" land grant entitling him to locate 160 acres of land. This was not bad pay for two weeks as a soldier. However, the 14-day private was not able to collect from the war office until June 1861, 13 years after his enlistment.

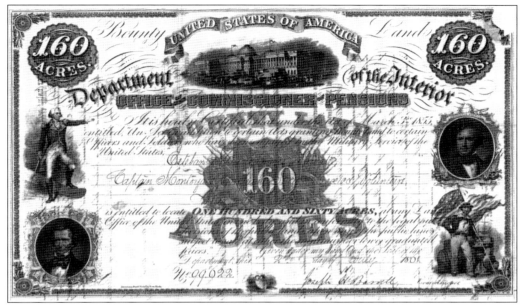

The Department of the Interior issued the above bounty land grant to Esteban Mansanares, entitling him to locate and claim 160 acres. These inducements for civilian service date to the Revolutionary War period and before. Gen. George Washington used bounty land grants extensively to pay his troops in cash-strapped colonial America.

The reverse side of the bounty land grant shows its sale and assignment of rights to Orange Risdon Jr. of Contra Costa County, California, on August 4, 1861. Manasares possessed the grant for less than two months before its sale. One can only wonder how much cash or trade the former volunteer private received for his 160-acre grant from the man from California.

MILITARY BOUNTY LAND ACT OF MARCH 3, 1855.

LAND WARRANT, No. 99,622

Register and Receiver's No. 164

Land Office, San Francisco Cal July 27th 1863

WE HEREBY CERTIFY, That the attached Military Bounty Land Warrant, No. 99,622 was on this day received at this office, from Orange Risdon of Contra Costa county, State of California

James M. Ross, Register.
Ralph S Dorr, Receiver.

I, Orange Risdon of Contra Costa county, State of California hereby apply to locate and do locate the S.W. ¼ of N.E. ¼ & S.E. ¼ of N.W. ¼ & N.W. ¼ of S.E. ¼ & N.E. ¼ of S.W. quarter of Section No. 15 in Township No. one South of Range No. three (3) East in the District of Lands subject to sale at the Land Office at San Francisco Cala containing 160 acres, in satisfaction of the attached Warrant numbered 99,622 issued under the act of March 3, 1855.

Witness my hand this 27th day of July A. D. 1863

Attest:
James M. Ross, Register.
Ralph S Dorr, Receiver.

O Risdon Jr

I request the Patent to be sent to

Land Office, San Francisco California 1863

WE HEREBY CERTIFY, That the above location is correct, being in accordance with law and instructions.

Ralph S Dorr, Receiver
James M. Ross, Register

Two years passed before Orange Risdon Jr. applied this military bounty land grant to the purchase of 160 acres in eastern Contra Costa County. Orange Jr. engaged as bookkeeper for his brother John at the boilermaker firm of Risdon and Coffey Locomotive Works in San Francisco. The Risdons hailed from Saline, Michigan, which their father surveyed, founded, and developed salt-mining operations.

> **SALT SPRING IN CONTRA COSTA COUNTY.**—The Contra Costa *Gazette* of December 6th remarks:
>
> Within a few days we have learned of a new discovery, or rather a movement to render available a discovery hitherto known to but few persons, we think, in the county. About five miles from the Marsh rancho, in a southeasterly direction, is a salt spring or lake, the hot water bubbling up in numerous jets. We are informed that an enterprising firm in San Francisco, after fully testing its saline properties, have located a section of land embracing the spring, with school warrants, and are making arrangements to commence the regular manufacture of salt.

Sodium is a key ingredient in metallurgy and iron manufacturing. Salt was commonly mined from ground deposits in the days prior to the San Francisco Bay salt-evaporation ponds. Commercial quantities of salt were mined along the northern coast of California and transported by water to San Francisco prior to railroad transportation. Owning a salt mine for the Risdons was the next best thing to owning an iron-ore mine.

The Risdons and their partners wasted no time in organizing their operation. Each of the partners claimed a 40-acre parcel and built improvements on adjacent corners surrounding the salt springs. Risdon paid for the land survey, the cost of improvements, and the filing fees. Each would share in company stock proportionately. Great plans were made for the salt mine but there was no economical way to transport salt overland to San Francisco so the plans are scrapped.

> Gazette * 1863
>
> **SALINE SALT MANUFACTURING AND MINING COMPANY.**—This company is formed for carrying on and conducting the business of manufacturing salt, and for mining in this State. Capital stock, $100,000, divided into 1,000 shares of $100 each. Trustees, John A. Risdon, William Ware, Lewis Coffee, L. Hagedon, and O. Risdon, Jr. We presume the point at which this company will commence operations, is in this county, near the Marsh Ranch. 3/21/1863 p. 2

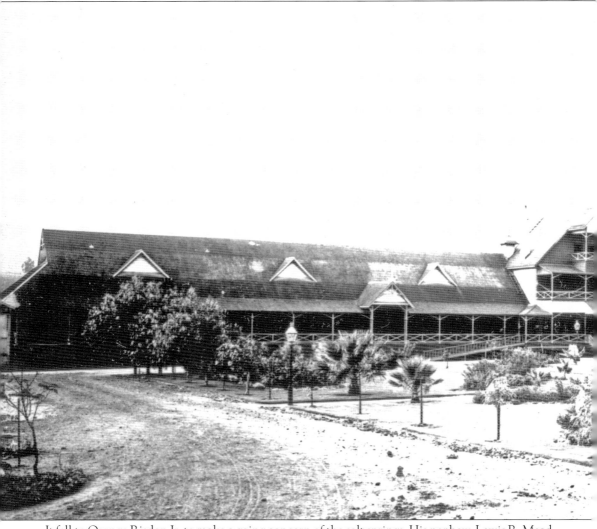

It fell to Orange Risdon Jr. to make a going concern of the salt springs. His nephew, Lewis R. Mead, the son of John and Orange Jr.'s only sister, Blanche, arrived from New Orleans in 1868 to follow his uncles in business. Orange and Lewis observed local residents and Native Americans camping and enjoying the springs. Many drank the waters; others soaked in the pools. No one was paying, and the loss of property rights to "squatters" was a real fear in early California. Efforts were made to allow access to the property on a fee basis. The minimally improved original building became

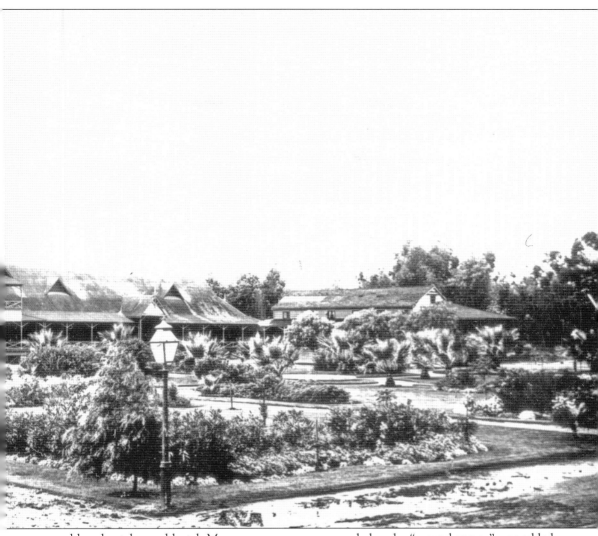

an ad hoc hostelry and hotel. More rooms were soon needed and a "second annex" was added to accommodate guests. This early photograph, c. 1878, shows the property under lease by H. C. and Amanda E. Gallagher. The sign over the "second annex," built to accommodate additional guests, reads, "Byron Springs Hotel." Seen here are the original four buildings constructed on adjacent corners of the four 40-acre parcels required to secure the 160-acre land patent.

The Civil War was over, and by the 1870s, California was connected to the rest of the nation via the transcontinental railroad. The gold rush was also over and immigrants flocked to California for its agricultural possibilities, healthful climate, and a new life. Orange Jr. and his nephew Lewis were exploiting the springs with Lewis leading most of the development.

To the Public:

THE best treatment of disease is that most in line with the restorative action of nature. Quality and quantity of result have, of late years, made natural methods more and more popular with physicians and patients. Among these natural methods one of the most important departments is the treatment by **MINERAL WATERS**, whether applied through the bath or by drinking. The efficacy of this mode has been so long and so thoroughly demonstrated, that to-day, the only question of importance to the invalid is the comparative value of the waters at the various health resorts. It is the object of this circular to direct attention to

BYRON SPRINGS,

AS PRE-EMINENTLY

THE NATURAL SANITARIUM

—OF—

California and the Pacific Coast.

This statement rests on a double basis:

First.—The curative properties of the waters, as shown by the fact that more and more lasting benefit has followed upon their use than in the case of any other similar resort west of the Rocky Mountains.

Second.—The happy combination of natural and artificial advantages which gives Byron Springs precedence to all competitors.

It will be found that these statements are borne out in brief in the following pages. If any further testimony is desired it will be cheerfully given in response to enquiries addressed to

C. R. MASON,
MANAGER BYRON SPRINGS HOTEL,
BYRON,
Contra Costa Co., Cal.

Medicinal Properties.

THE healing virtue of the waters of Byron Springs is known to all physicians who have used them in combating disease, as also to the general public through the great number

The Byron Hot Springs Resort expanded to accommodate health seekers with more and more amenities. Tents were provided and guest lodging improved. Bathhouses were constructed and specific springs identified and analyzed. Wagons and horses brought locals and invalids seeking relief from all that ailed them. With few doctors in the state and few oral medications, a "natural" sanitarium meant relief from arthritis, rheumatism, joint pain, internal complaints, or other ailments.

DEATHS.

At San Luis Obispo, April 27th, Orange Risdon, Jr.

☞ His friends and those of his brother J. N. Risdon, are respectfully invited to attend the funeral to-morrow (Sunday) at 2 o'clock P.M., from the residence of J. N. Risden, 213 Harrison street, without further notice.

In this city, May 12th, Green Hill, youngest son of Mary B. and the late Col. B. F. Moore, aged 7 weeks.

☞ The funeral will take place to-morrow (Sunday) at 2 o'clock P.M. from the residence of D. O. McCarthy, 1429 Taylor street.

In the city of New York, April 10th, Thomas Downing, a native of Accomac county, Virginia, aged 73 years.

In this city, May 11th, Mrs. Mary Sarsfield, a native of Ireland, aged 78 years.

In Stockton, May 8th, Phil. William, son of Patrick and Ellen Brady, aged 6 months and 18 days.

Orange Risdon Jr. died on April 27, 1866, at age 36 on a business trip to San Luis Obispo. The *San Francisco Call* newspaper provided this funeral notice. Orange must have been well known in both San Francisco and the Comstock Lode, as the Risdon Iron Works was the largest manufacturer of dredges, pumps, and machinery to the Silver State mining industry. To his family's surprise, Orange claimed title to the Salt Springs in his name only.

Orange Risdon Sr. was the beneficiary of his deceased son's estate. Orange Jr. died intestate (without heirs) requiring all his assets go to his next of kin. His sole asset, with the exception of some small savings, was the 160-acre salt springs property. His nephew, Lewis R. Mead, moved quickly to have himself appointed administrator of the estate by the probate court.

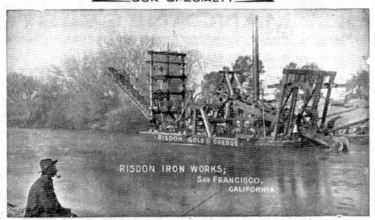

The Risdon family business thrived in imperial San Francisco. It was one of the largest employers in the city and provided placer and hardrock mining equipment throughout the West. Eventually Risdon equipment was found in South America and Alaska. A Risdon Gold Dredge, pictured here, was still in operation in Alaska in the 1960s. The firm expanded into shipbuilding, steel-girder manufacturing, and water-pipe construction.

Lewis R. Mead, at 21 years of age, stepped into his uncle Orange Jr.'s responsibilities at the Risdon Iron and Locomotive Works. He divided his time between the salt springs and San Francisco while maintaining his legal residence at Byron according to voter registration records of the time. Eventually Mead became the corporate secretary for the incorporated Risdon Iron Works.

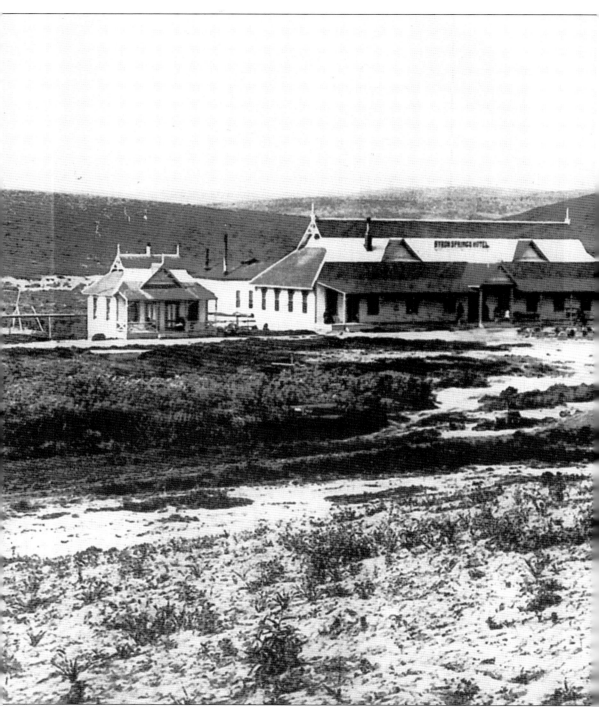

This rare 1878 photograph of Mead's Hot Salt Springs, referred to today as the First Hotel, incorporates the original guest structures and the second annex all under one roof. Newspaper accounts of the time report construction costs of $50,000. The hotel structure is essentially one gigantic remodeling that incorporates all three original structures. All rooms face outward toward

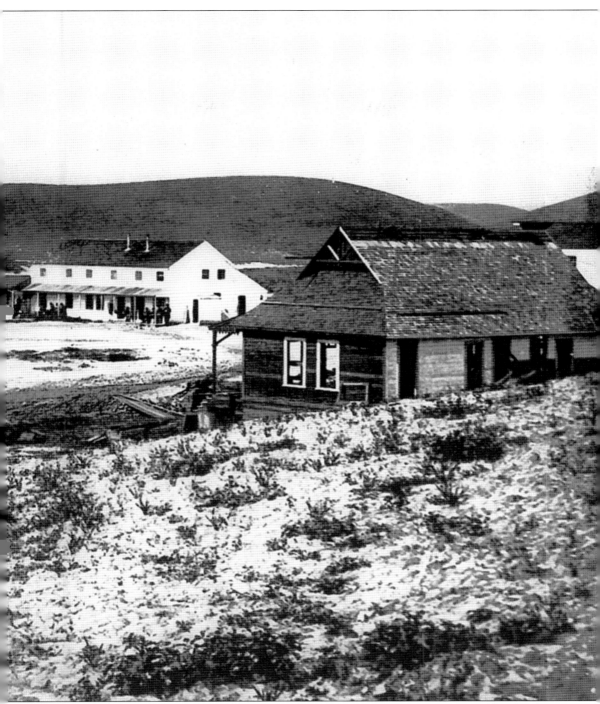

the veranda. The new third floor is reserved for the resident manager, D. R. Mason, and his family. The structural similarities to the Hotel Del Coronado are palpable as its architect, James Reid, who was Mead's best friend. Reid subsequently designed the Second and Third Hotels and the marble Mead Memorial Building, which was also known as the liver and kidney building.

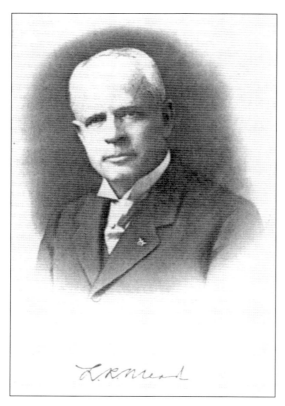

Mead, with his dual role as secretary of the Risdon Iron Works and proprietor of the Mead Hot Salt Springs, was a prosperous man. This photograph, taken later in his life, shows him as the prosperous "clubman" that he was known as in San Francisco Society Blue Books of the era. His lapel pin is that of a Masonic Shriner; Mead was a founding member of the organization in San Francisco.

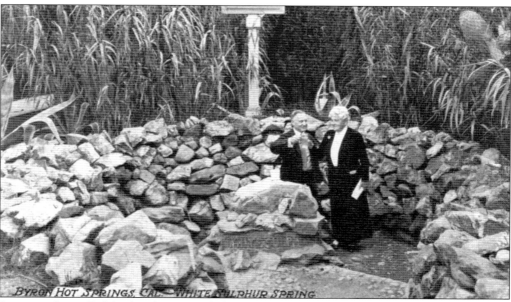

Proprietor Lewis R. Mead and a woman believed to be his first wife, Blanche Durant Mead, stand in the well of the white sulphur springs and toast one another with a tall glass of mineral water. Their smiles are deceiving as the predominant smell of rotten eggs at the spring must have been overwhelming. Lewis Mead was a master of marketing as this early (pre-1905) postcard illustrates.

Nineteenth-century America was enthralled with the European concept of spas, sanitariums, and water cures. Mead saw the opportunity to increase the number of guests drawn to the hotel and springs by drawing upon a national population base. He saw his chance by advertising in the new *Overland Monthly* magazine in March 1891. Among its contributors were Mark Twain and Bret Harte.

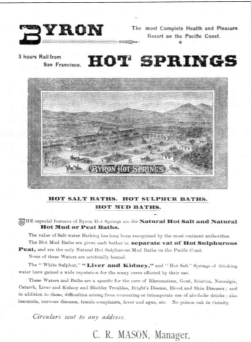

Mead's Hot Salt Springs was rechristened in the early 1890s as Byron Hot Springs—a name it retains to this day. The circular referred to in the advertisement is a 10-page, letter-set brochure with engraved images of healthy visitors. The locale was completely up-to-date, featuring people on bicycles, which was the latest craze. Note the lack of poison oak.

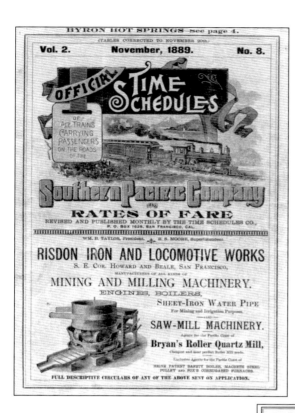

Mead's hand in the management and ownership of both the Risdon Iron Works and Byron Hot Springs is evident in this cover from the November 1889 Southern Pacific timetable. The ironworks has the feature advertisement, but the hot springs has the heading. Mead oftentimes maximized his hot springs advertising dollar with a corollary ad placed next to a more expensive ironworks advertisement.

Inside the Southern Pacific timetable, Mead ran a full layout advertisement featuring the often-used engraving of the hot springs' First Hotel and grounds. Byron Hot Springs appears on page four and the rival Hotel Del Monte appears on page 15. Mead maintained a friendly rivalry with the Southern Pacific-owned Hotel Del Monte in all his promotional material. If the Hotel Del Monte had a spot in the timetable, Byron Hot Springs would too.

ANALYSES OF THE SPRINGS

Dr. Winslow Anderson, Analyst, 1889

HOT SALT SPRING

Mineral Ingredients	U. S. gal. contains grains	Mineral Ingredients	U. S. gal. contains grains
Sodium Chloride	555.26	Calcium Carbonate	.68
Sodium Carbonate	0.21	Calcium Sulphate	.85
Potassium Chloride	36.02	Ferrous Carbonate	.86
Potassium Bromide	trace	Ammonium Chloride	.09
Potassium Iodide	0.03	Barium Carbonate	.17
Magnesium Chloride	2.06	Silica	2.00
Magnesium Carbonate	12.11	Organic Matter	.06
Calcium Chloride	96.64	Total Solids	706.94

Gases { Free Carbonic Acid Gas 3.00 Cubic Inches

Alkaline and Chalybeate Water

TEMPERATURE, 70 8 DEG. F.

Mineral Ingredients	U. S. gal. contains grains
Sodium Chloride	670.43
Sodium Sulphate	trace
Sodium Carbonate	trace
Potassium Chloride	48.05
Potassium Sulphate	trace
Potassium Bromide	trace
Potassium Iodide	.04
Magnesium Chloride	1.82
Magnesium Carbonate	15.94
Calcium Chloride	9.75
Calcium Sulphate	10.80
Calcium Carbonate	6.03
Ferrum Peroxide	.43
Barium Carbonate	trace
Ammonium Chloride	trace
Silica	2.29
Organic Matter	.06
Total Solids	765.64

Gases { Carbonic Acid Gas 25.00 } Cubic Inches
 { Sulphureted Hydrogen ... 12.95 }

SURPRISE SPRING

Mineral Ingredients	U. S. gal. contains grains
Sodium Chloride	15,417.03
Sodium Carbonate
Potassium Chloride	142.00
Potassium Bromide	0.06
Potassium Iodide	.13
Magnesium Chloride	622.56
Magnesium Carbonate	151.92
Calcium Chloride	2,364.77
Calcium Carbonate	5.42
Calcium Sulphate	66.14
Ferrous Carbonate	2.72
Ammonium Chloride	trace
Barium Carbonate	trace
Barium Chloride	0.13
Silica	0.85
Organic Matter	trace
Total Solids	18,773.73

Gases { Free Carbonic Acid Gas trace

The waters taken at the springs were its first commercial draw, and Mead promoted their efficacy. Dr. Winslow Anderson first analyzed the waters and featured them and the attractions of Byron Hot Springs in his illustrated prized essay entitled, *Mineral Springs and Health Resorts of California*. Anderson's enthusiasm was not coincidental as he resided at the springs according to voting registration records of the era.

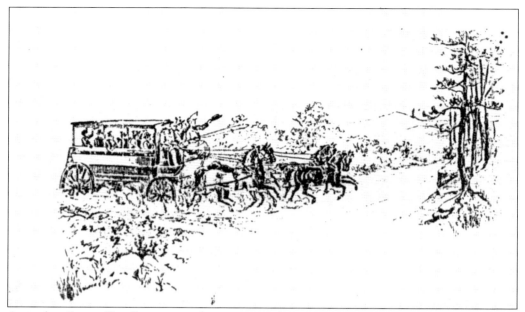

Arrival at Byron Hot Springs was by commercial stage service beginning in 1877. Amanda Gallagher secured transport for the two-mile drive to the hot salt springs. In this early engraving, eager guests are seen enjoying what must have been a dusty trek over alkali sand and rabbit brush. No wonder they were pleased to arrive at the oasis Mead created.

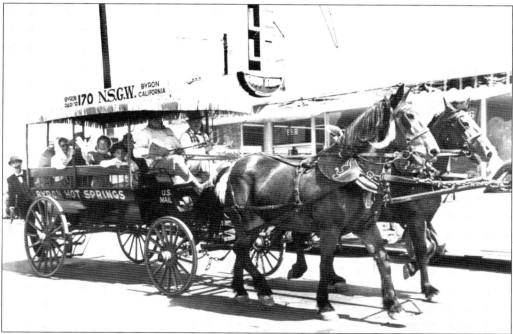

This same guest carriage rolls along 70 years later on the streets of Concord, California, as part of the Native Sons and Daughters of the Golden West Pow Wow parade around 1955. The carriage holds members of the Donner chapter from Byron. The wagon still exists today, no doubt hidden away in a member's barn awaiting the next parade.

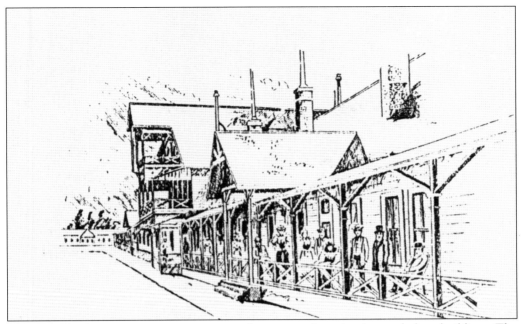

The First Hotel was not just a continuous roof over several previously stand-alone buildings. The structure had 50 rooms, all on the first floor. Each room was steam heated, and all faced what was to become the Palm Court. Mead lost no time in improving the property after securing fee simple ownership from his grandfather, Orange Risdon Sr., by U.S. superior court action in January 1885.

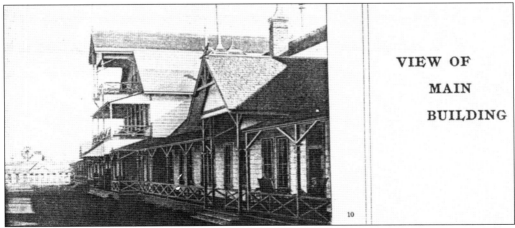

The resort had a unique feature not found in similar resorts: a resident physician. Dr. Robert Crees was the first resident physician caring for patients. Mead recruited the best hydropaths and dermatologists of the time, all from the new University of California Medical School. The doctor's office was on the first floor.

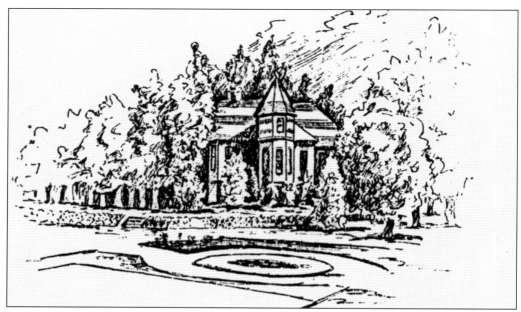

Happiness comes in many ways. Mead built a cottage for his wife, Blanche (née Durant) Mead, in 1886. Later, when Byron Hot Springs incorporated on December 23, 1903, Blanche retained a life estate in the cottage as her sole and separate property. She passed away there in 1905 the day after Christmas in the presence of her husband and son.

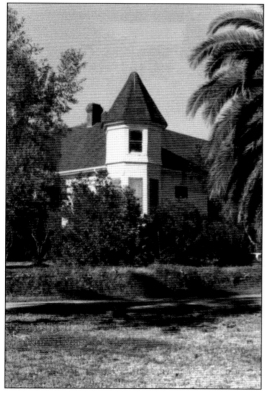

Often called the Mead Mansion, this small Queen Anne cottage featured stained glass, peacock-patterned wallpaper, wood floors, a basement, and small bedrooms. No kitchen was necessary as the original proprietors took their meals at the hotel or had them sent in. Later owners added a kitchen, an entertainment room, and laundry rooms. Tragically this 120-year-old cottage was destroyed by fire in 2005.

Happiness attended Lewis and Blanche Mead with the arrival of their son, Louis Durant Mead, on March 31, 1875. Louis was a graduate of the University of California, Berkeley, class of 1896. This was his senior year photograph taken from the *Golden Bear* yearbook of 1896. He went on to study medicine at New York University, specializing, not surprisingly, in hydropathy.

DR. LOUIS D. MEAD,
Visiting Physician Isolation Hospital

Dr. Louis Mead, resident physician of Byron Hot Springs, was socially prominent in his own right. He and his wife, Charlotte Lanneau, a medical nurse, also maintained a residence in San Francisco where Lewis had a separate medical practice. They had one child, Blanche, named after her grandmother. Louis Mead died at the springs in 1916 of "softening of the brain."

Good times at Byron Hot Springs were had, as proclaimed in the highly popular weekly *The Wasp*. The publication was known for its editorials, opinions, and political stance. Lewis Mead must have been in the midst of it as a leading capitalist and clubman. His membership in the leading men's clubs of the day attracted leading citizens to Byron Hot Springs for rest, recreation, and politics.

> BYRON SPRINGS, 3 HOURS RAIL FROM SAN Francisco. New management; hotel newly furnished. Hot salt, hot mud and sulphur baths.

This advertisement from *The Wasp* says it all, "Hot salt, hot mud" . . . and a hot time. Rail service directly to the Byron Hot Springs Railroad Station began shortly after the Southern Pacific Railroad acquired the San Pablo and Tulare railroads. An official U.S. Post Office opened on August 17, 1889. At any particular time, the guest population at Byron Hot Springs exceeded the population of the hamlet of Byron.

Two

"Taking the Cure"

A day at the spa, nine holes of golf, fine dining, and relaxation epitomize 21st-century resort living. Byron Hot Springs was at the cutting edge of what is now called "resort life" when it was established in 1868. In today's fast-paced world, a pill is taken for joint pain and people keep on working. In 19th-century California, a person checked into the springs, sought the good doctor for a water-therapy prescription, and relaxed for the week.

Hydropathy, the internal and external use of water for the treatment of disease, was all the rage in Europe between 1820 and 1860. All levels of society in late 19th- and early 20th-century America sought water-cure relief for rheumatism, asthma, arthritis, and more. The hydropathic system consisted of three basic treatments: application of water by bath (a heated pool or peat bath), application to a particular part of the body (by compress or poultice), and internal cleansing (through drinking or catharsis). Apparently hydropathy had no major adverse effects on those who subscribed to it and it produced some benefits. Early Americans did not bathe regularly and water treatment helped to reduce the spread of disease. Combining "the waters," fresh air, and as much exercise as the invalid could sustain had a curative effect at a time when frailty was the norm.

Spring resorts were very fashionable in Europe. Sanitariums, combining hospital, resort, and spa, flourished at Baden Baden and Carlsbad, Germany. Overseas travel was dead, however, and sanitariums like Byron rivaled their continental equivalents. Medical research and local boosters furthermore proclaimed the United States versions better.

Byron Hot Springs had it all. The *San Francisco Daily Call* ran weekly health articles on water treatments, all of which could be experienced at Byron. A resident physician lived on-site up until the late 1930s to prescribe hydropathic treatments. All of the physicians of Byron Hot Springs were leading medical practitioners of their day. If there was too much consumption of alcohol, there was always a cure. Is Prohibition too restrictive? Joseph Kennedy bootleg whisky was available to alleviate any pining. A person could arrive on crutches and walk out completely revived.

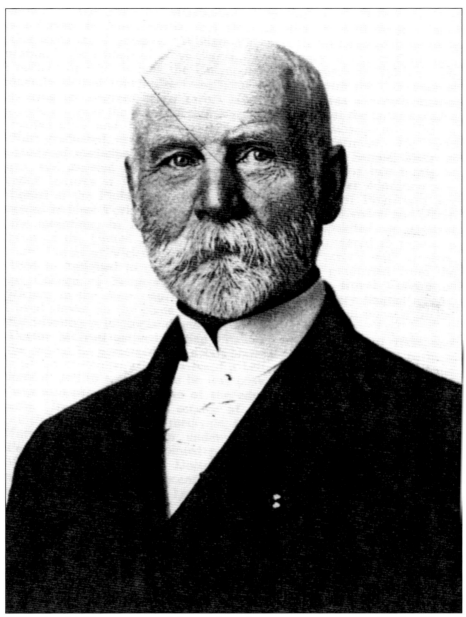

Dr. W. Fletcher McNutt was one of the guiding physicians overseeing patient health at Byron Hot Springs. He and fellow physician Winslow Anderson maintained a private sanitarium, a 19th-century equivalent of a hospital, in San Francisco. Both were friends of Lewis Mead and lent their substantial influence to ensuring the success of the "Home of Health." McNutt trained as a surgeon at the University of Edinburgh, Scotland, and was a founder of the University of California Medical School in San Francisco. He was present for both the birth and death of Dr. Louis Durant Mead. He served as the Byron Hot Springs resident physician in 1919. Later in life, McNutt was appointed warden of the California prison system. Enlightened opinion in the 1920s suggested criminals were mentally deficient and that hygiene and cleanliness in the prisons aided reform. Who better to head the California prison system than a physician?

Drink the World-Famous Mineral Waters!

AT BYRON HOT SPRINGS

Medically Recommended in Treatment of **RHEUMATISM, ARTHRITIS, NEURITIS, SCIATICA, KIDNEY TROUBLE** *and* **NERVOUS DISORDERS**

Since 1860, thousands who have had health problems have found in Byron, a "Carlsbad of America". Not only have miraculous cures been effected (particularly in cases of rheumatism, gout, sciatica, constipation and liver and liver and kidney disorders) but people from all parts of the world have returned to Byron and set aside a part of their time to devote to *keeping* their health.

The Springs at Byron are among the many natural wonders of the State of California. Being centrally located and within easy access — one and one-half hours from San Francisco — Byron is much visited by Tourists.

The famous springs became renowned many years before the Spanish invasion. Our Indians hand down traditions of the cures effected by the waters. The Indian used to travel many miles to bathe in the mud and drink the waters.

OVER FIFTY SPRINGS AT BYRON

There are more than fifty springs or outlets from the subterranean passages, although only seven are in active use. They range in temperature from 52° F. to 140° F. One of the most important of these is the "liver and kidney" spring. It is so named because of the beneficial action of the water on these organs. This spring has been used for years by people coming to this area and carrying away the water in bottles and barrels for medicinal use. This water, taken at 10 A.M. and 4 P.M. daily, relieves rheumatism, gout, sciatica, diabetes, lumbago and similar troubles. It also regulates the liver, kidneys and bladder.

NATURAL HOT SALT LAXATIVE SPRING WATER

Three to five glasses of this water taken one hour before breakfast produces a prompt, gentle and thorough result. It is non habit forming and acts at once. The primary function of this water is the elimination of excess acid in the system. The mineral salts, heavy in solids content, cling to the stomach walls and are directly absorbed into the system by digestion. The Laxative effect is secondary, aiding in the digestion.

WHITE SULPHUR SPRING WATER

This water may be taken at any time and is particularly good when taking the baths as it induces profuse perspiration. It relieves acid stomach, is a blood purifier, skin softener, and is fine for shampooing the hair.

RESIDENT PHYSICIAN IN CHARGE

Before taking the waters and baths guests are privileged to consult with the resident physician without charge.
Recreational activities are plentiful at Byron, both indoor and outdoor.

BYRON MINERAL BATHS ARE WORLD FAMOUS

Thousands of visitors are coming regularly to Byron for a course of the world famous health waters and mineral baths.

Relief is being secured and actual cures are being effected by the baths in cases of rheumatism, gout, liver disorders, malaria, diabetes, lumbago, bladder and kidney disorders, sciatica, stomach disorders, neuralgia and arthritis.

The combination of the mineral water baths, the peat (mud) baths, the sun baths, and the pure mineral drinking waters just as they flow from the springs is proving a boon to thousands each year.

HOW THE MINERAL BATHS HELP YOU

The mineral bath quickly raises the skin temperature and gradually that of the deeper tissues, with a steady dilation of the blood vessels, first in the skin, then in the deeper muscles bones and organs. The stagnant blood is forced on, relieving congestion, swelling, pain and flushing away accumulated toxins (as in arthritis).

NATURAL HOT SALT BATHS RELIEVES RHEUMATISM

This water is alkalo-chlorinated. These baths are located on the first floor of the hotel and contain rooms for blanket sweats and massage treatments. The attendants, both male and female, in charge of the baths are experts in their line of work. These baths have been very successful in securing relief from rheumatism, gout and joint diseases.

HOT PEAT (MUD) BATHS, WORLD FAMOUS

The most noted of the baths are the famous mud baths. They are individually constructed in a separate building and temperature varies from tepid to 140° F. The mud is a clean flaky peat and washes from the body like sand. The baths are built over living springs and complete immersion can be secured. Expert attendants supervise each treatment.

BATHING FACILITIES A SPECIAL FEATURE

Baths may be taken either on the first floor of the Hotel or in large modern bathhouses built for treatments. The baths, either sulphurous, mud, or mineral water, in tub or plunge, can be taken at all temperatures. The swimming plunge is built over a sulphur spring, thus assuring fresh running mineral water in the pool at all times.

What few unpleasant days we have climatically are no inconvenience to the patrons of Byron Hot Springs. The waters are delivered to the rooms, the mineral baths are on the ground floor, transportation is furnished to the mud baths. The hotel is steam heated and equipped with elevators. Patrons are just as comfortable at Byron as they are in their own homes.

Before modern pharmaceuticals, it was common practice for individuals to douse themselves at home with gaseous or still waters heavily laden with salts and metals. It is still done today with Alka Seltzer® or bottled carbonated water. Byron Hot Springs offered a full selection of waters under written medical prescription. This was no medical quackery by 19th- and early 20th-century standards. The resident physician of the springs was trained at a university medical school, licensed by the medical board, and was a member of the county medical association. No mineral-water bottling plant existed on the property to capture mineral waters for distribution. Amazingly Mead missed this one marketing opportunity. He served Calso® and Calistoga® water in the dining room. Bottles for filling at the springs and returning to one's room were provided. Mud baths were available as were rubdowns with mineral water. The salt plunge for bathing was built over a sulfur spring in 1868.

This rock and mortar "igloo" is not at all what it appears. The structure covers a natural spring known in yesteryear as the black sulfur spring. Guests at the resort would step down into the spring and retrieve a dipper of water to drink. There were no paper cups or door, just the spring and a metal dipper hung from a hook.

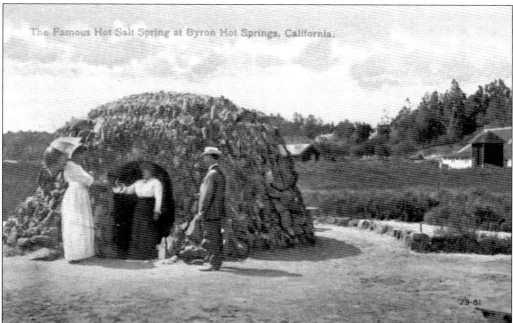

The black sulfur spring continued as an attraction into the 1910s. This image was part of a modern electric "light box" display promoting Byron Hot Springs at the Contra Costa County exhibit at the Panama Pacific International Exhibition in San Francisco. The author believes the individuals enjoying the waters are members of the Mead family. Dr. Louis Mead is on the right. One of the two women may be his wife, Charlotte.

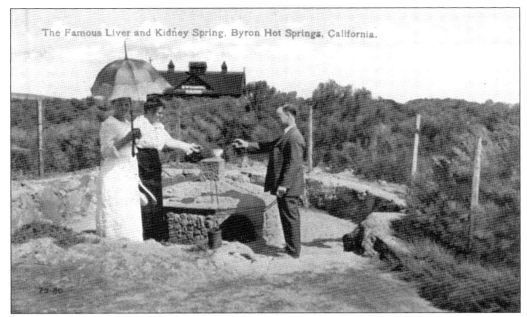

Individuals once more enjoy a dipper of spring water, this time from the Liver and Kidney Spring. A masonry enclave shields the spring. Still, the entry is open to the elements. One sip from this spring and the guest may find his or her liver and kidneys restored from alcoholic overindulgence. Many came to the resort for just such a cure.

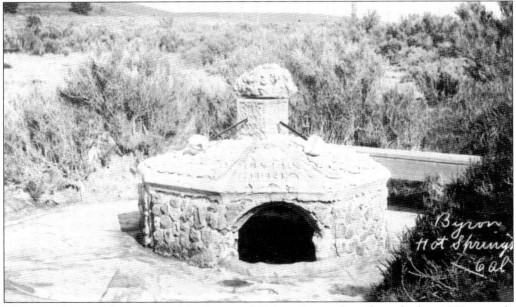

This rare photograph postcard of the Liver and Kidney Spring dates from the late 1800s or early 1900s. Note the two metal dippers resting on top of the cavern. The dippers give an idea of the small size of the spring. Perhaps it was five feet in diameter and three feet high. The words "liver" and "kidney" are spelled in rocks on the casing. Note the benches provided for invalids.

ANALYSES OF WATERS AT BYRON HOT SPRINGS

by Curtis & Tompkins, Ltd.

HOT SALT SPRING
The water has a temperature of 122° F.

	GRS. PER GAL.		GRS. PER GAL.
Ammonium Chloride	1.78	Calcium Chloride	106.00
Lithium Chloride	4.20	Calcium Sulphate	Trace
Potassium Bromide	1.55	Calcium Phosphate	Trace
Potassium Iodide	1.24	Calcium Bi-carbonate	10.42
Potassium Chloride	2.13	Ferrous Bi-carbonate	0.47
Sodium Chloride	572.00	Barium Bi-carbonate	0.68
Sodium Meta-borate	4.29	Strontium Bi-carbonate	0.12
Magnesium Chloride	24.95	Silica	1.74
TOTAL			731.57

GAS
	C.C. PER LITER
Free Carbon Dioxide	4.45
Free Hydrogen Sulphide	0.41

LIVER AND KIDNEY SPRING
The water has a temperature of 58° F.

	GRS. PER GAL.		GRS. PER GAL.
Ammonium Chloride	2.23	Calcium Chloride	81.21
Lithium Chloride	0.72	Calcium Sulphate	Trace
Potassium Bromide	1.59	Calcium Phosphate	Trace
Potassium Iodide	1.26	Calcium Bi-carbonate	18.85
Potassium Chloride	3.18	Ferrous Bi-carbonate	0.60
Sodium Chloride	639.52	Barium Bi-Carbonate	0.86
Sodium Meta-borate	6.14	Strontium Bi-carbonate	0.13
Magnesium Chloride	29.57	Silica	1.80
TOTAL			787.66

GAS
	C.C. PER LITER
Free Carbon Dioxide	7.23
Free Hydrogen Sulphide	0.28

Dr. Winslow Anderson's chemical analysis of the many mineral springs at Byron was the authoritative last word on their contents. His analysis was used in Byron Hot Springs brochures up until the late 1930s to describe the restorative properties of the waters. Interestingly, recent chemical analysis of existing springs on the property is very near to Anderson's analysis from over a century ago. Outdoor privies were a standard feature at the resort and were located behind the main hotel. They were relatively close to the springs, too, making a fast repair to comfort possible. Modern indoor plumbing was provided in the Moorish-style Second Hotel and the current brick Third Hotel. The U.S. Army installed a major sewage system during their tenure at Camp Tracy. The Surprise Springs have a rapid purgative effect, and a local Byron resident as recently as the 1960s knew its location and sought its liquid relief.

The rather rustic mortar- and rock-covered spring with tin water dippers received an upgrade after Lewis Mead died in 1918. His widow, Mae, built the Mead Memorial to her late husband with brick exterior, Alaskan marble interior, and gold leaf at a reported cost of $10,000. Architect James Reid once again provided the design. This photograph shows one end of the building after vandals removed the marble walls.

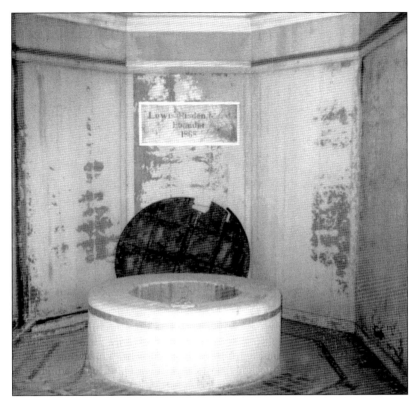

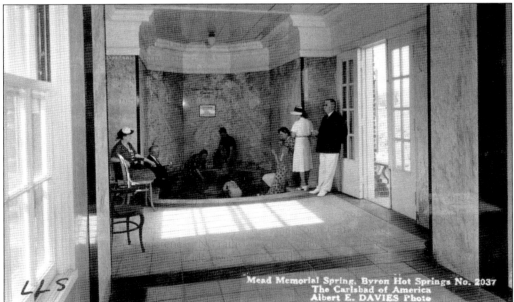

This 1930s postcard shows the opposite end of the Mead Memorial in its marble splendor. Visitors are able to step down into the spring, but once again, individuals, including the little girl, are drinking, not bathing, in the water. Note the presence of a white-capped, uniformed nurse. Byron is incredibly hot in the summer, and this marble-lined room provided welcome relief.

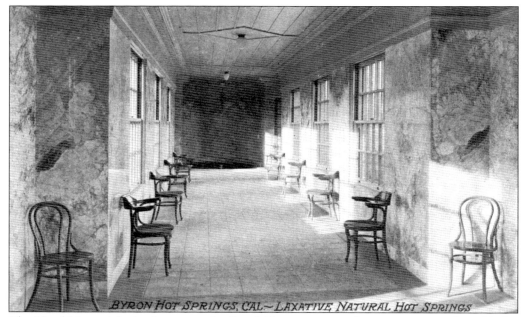

The Mead Memorial, also known as the liver/kidney room, was long, spacious, cool, and light-filled. It held a combination medical room, sanctuary, and baptismal quality for its visitors. The concept of "drinking at the well" has religious overtures to some. Perhaps for this reason, the Greek Orthodox church sanctified the building into "the life-giving spring" during the resort's tenure as Mission St. Paul.

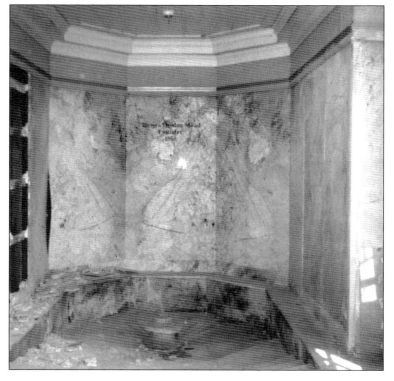

The young bride, Mae Sadler, adored her husband, Lewis, who was almost 40 years her senior. Lewis Mead's name and birth and death dates as seen here are inscribed in marble and picked out in gold leaf. Signs proclaiming Lewis Mead as founder in 1868 of Byron Hot Springs were found throughout the property. A large portrait of Mead hung in the hotel lobby.

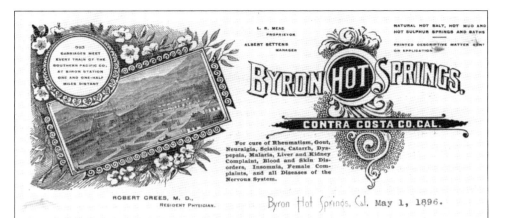

Lewis Mead did everything possible to ensure the reputation of Byron Hot Springs as a health sanitarium. This letter to Dr. Carrie Young of Berkeley assures her of the quality physician engaged at the springs. Nineteenth-century health sanitariums were the equivalent of 21st-century luxury spas. Then, as now, medical staff under the direction of a licensed medical doctor specializing in dermatology saw to a patient's treatment. Byron Hot Springs had peat mud baths where the peat dirt was changed after every use. Hot water soaks were a hydropathic aid for psoriasis sufferers. Hot towels soaked in mineral water sweat the pounds off the reducer. Regular meals were available and special diets recommended for those taking a "slimming cure." Nurses were on staff, and all springs and buildings were handicapped accessible, 100 years before the Aid to Disabled Persons Act was passed.

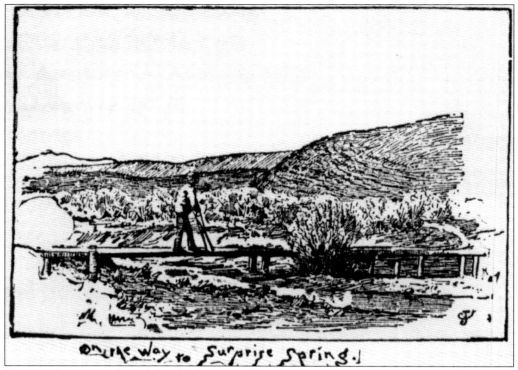

This crutch-supported invalid makes his way to the Surprise Spring for a treatment. Wooden ramps and sidewalks were placed to ease walking through the alkali bog. He hopes that the surprise in store releases him from his infirmities. The "milk of magnesia" effect of the waters could give a surprise he wouldn't relish.

A huddled woman patient stands in front of the infirmary building dressed warmly in a heavy black coat. She watches a young child dressed in light linen clothes play along the wooden sidewalk. Age seeks relief as youth frolics is a recurrent theme at the springs.

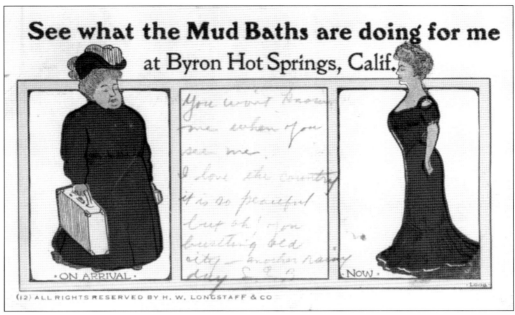

The healthy life at the springs worked wonders for women, too. Many took the "slimming" cure as this postcard dated March 21, 1910, tells a friend in Carson City, Nevada. "You won't know me when you see me. I love the country, it is so peaceful but oh! You bustling old city—another rainy day. [signed] L. A. B [Author's addition].

WHITE SULPHUR SPRING
The water has a temperature of 70° F.

	GRS. PER GAL.		GRS. PER GAL.
Ammonium Chloride	0.02	Sodium Carbonate	1.38
Potassium Bromide	0.16	Sodium Bi-carbonate	19.71
Potassium Iodide	0.16	Calcium Phosphate	0.10
Potassium Chloride	0.37	Magnesium Bi-carbonate	3.07
Sodium Chloride	17.92	Calcium Bi-carbonate	3.47
Sodium Meta-borate	1.47	Ferrous Bi-carbonate	0.60
Sodium Sulphide	0.88	Barium Bi-carbonate	
Sodium Sulphate	5.13	Silica	2.70
TOTAL			56.82

GAS	C.C. PER LITER
Free Carbon Dioxide	None
Free Hydrogen Sulphide	16.70

According to Dr. Winslow Anderson, the "light alkalo-sulphurous water is palatable and invigorating, containing a large quantity of ferruginous salt, so necessary in strumous diathesis, rheumatism, gout, chronic malarial poisons, and cutaneous diseases. It is useful in treating rheumatism, chronic joint diseases, glandular enlargements and many forms of skin disease. Its action is tonic, diuretic, alterative, aperient, and antacid. It should be taken between meals in six or eight ounce doses."

This brochure from the 1915 to 1920 era assures that "cures are realities at Byron Hot Springs." The combination of the mineral and mud baths, the pure mineral drinking waters that have health in every drop, a massage, a sun bath, the pure country air, and delicious, palatable food were all conducive to a sound, restful sleep in peaceful quiet and promised benefit beyond expectations.

RATES
AMERICAN PLAN
(With Meals)

	Daily		Weekly	
HOTEL ROOMS	SINGLE	DOUBLE	SINGLE	DOUBLE
Without bath	$5.00	$9.50	$30.00	$57.00
With bath	6.00	11.50	36.00	69.00

	Daily		Weekly	
COTTAGE ROOMS	SINGLE	DOUBLE	SINGLE	DOUBLE
Without bath	$4.00	$7.50	$24.00	$45.00
With bath	5.00	9.50	30.00	57.00

All rooms in hotel have private lavatory, hot and cold running water.

MONTHLY RATES: Four weeks or more; 10% discount.

UNEXCELLED CUISINE—*Delicious Food*

Transient meals: Breakfast $.75; Luncheon $1.00; Dinner $1.25.

BATH SERVICE:
- Hot Salt Bath — $.50
- Blanket Sweat — .50
- Mud Bath — 1.00
- Mud Pack — 1.00
- Alcohol or Other Rubs — 1.50
- Massage — 1.50

GARAGE:
Individual garages for the accommodation of our guests

TRAIN SERVICE:
Southern Pacific trains to and from BYRON HOT SPRINGS. Current schedule and rates furnished on request.

Hotel conveyance meets trains without charge.

TELEPHONE SERVICE:
Twenty-four hours a day.

BYRON HOT SPRINGS
UNDER MANAGEMENT OF
ALBERT ICHELSON
ALSO MANAGING RICHELIEU HOTEL, SAN FRANCISCO
Famous for its delicious food

Accommodations at Byron Hot Springs definitely improved after 1890 and so did the prices. The resort did not market to local east Contra Costa County residents. They provided the vegetables, eggs, and meat for the aptly described "delicious, palatable food," but the resort was for those from out of town. Note the new automobile garage service.

Mud baths were very popular and part of the medical regime at Byron Hot Springs. This modest building is one of the first structures built over the springs to formalize the bathing experience. It stood for years until owner Mansour Hakimi tore it down in March 1978 to use the marble for a proposed new, larger indoor plunge.

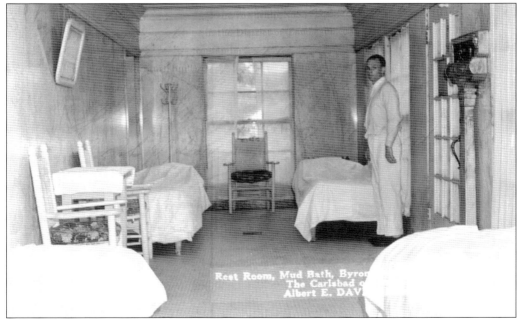

The interior of the mud bath house was as clean as a hospital. An attendant stood ready to assist with a mud pack, mud bath, blanket sweat, massage, or rub. There was no muddy hole in the ground in which to sit. The tub filled with mineral water and peat mud stood draped to the rear left. The San Joaquin Valley between Byron and Stockton is all peat dirt.

"HOT MUD SPRING" Analysis by Dr. Winslow Anderson. Expressed in Grains, per Gallon	
Sodium Chloride	274.93
Sodium Sulphate	42.16
Potassium Chloride	26.40
Potassium Iodide	.32
Potassium Bromide	trace
Magnesium Chloride	2.06
Magnesium Sulphate	19.60
Calcium Chloride	7.50
Calcium Sulphate	36.05
Calcium Carbonate	3.09
Ferrous Sulphate	.76
Ammonium Chloride	trace
Silica	5.62
Organic Matter	7.34
Total Solids	425.83
Cubic inches Free Carbonic Acid Gas	17.75
Cubic inches Free Sulphureted Hydrogen	14.50

Dr. Winslow Anderson provides a description of the "Hot Mud Spring" as "black sulphurous mud—salino-sulphurous mud water at 110 degrees Fahrenheit was the most noted of all. Baths were constructed such that complete immersion could be achieved and the temperature carefully regulated. The hot mud is famous in the treatment of rheumatism, gout, swollen joints, chronic arthritis, scrofula, and skin diseases."

An attendant wheels a bathtub of hot sulphurous mud into a treatment room at the Moorish-style Second Hotel. The treatment rooms were on the lower level and adjacent to the medical offices for easy supervision. Note the bathtubs are track-mounted for ease of movement. Mud bath tubs were physically transported in the same way as ore-mining carts so familiar to the owners of the Risdon Iron Works.

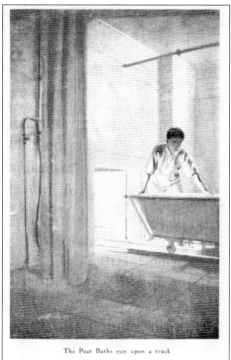

The Peat Baths run upon a track

> **Byron Hot Springs Sanitarium.**
>
> L. R. MEAD, Proprietor. R. CREES, M. D., Resident Physician.
>
> **Course of Treatment.**
>
> For *R. C. Downs*
>
> Beginning *May 3rd* 1898
>
> Drink 1 to 2 dippers of Hot Salt Water before breakfast every morning.
>
> Drink 1 to 2 dippers of *Liver & Kidney water* at 11 A. M. and 5 P. M. daily.
>
> Baths: 1st day *Hot Salt bath at 100 deg*
> 2d " " " " " *103"*
> 3d " " " " " *106"*
>
> ~~Then take a~~ *mud bath every 2nd day* until further instructed. *Have a massage 3 times a week.*
>
> Take your baths between 2 and 3 hours after eating.
>
> After taking a bath always go to your room and lie down for and hour or two to avoid taking cold.

Consuming the correct type of mineral water in the correct dosage at the correct time was serious business at the springs. This "prescription" for a daily regime of waters and massage was, indeed, a true medical prescription of its time. True, this prescription couldn't be filled at the local pharmacy, but a "patient" was at the treating sanitarium.

Medical examination for each guest was included in the cost of the stay. No additional charges were applied to a guest's bill for medical advice on their condition, whatever it might have been. Laboratory tests were conducted at material cost, excluding labor, and drugs were dispensed at cost. Moreover, a licensed medical doctor specializing in dermatology provided all services. Modern medi-spa facility managers would swoon at the lost revenue.

> The resident physician can be found in his office every day from 9:30 to 10:30 A. M., and from 2 to 3 P. M., to advise guests as to the proper course of treatment.
>
> Guests must not hesitate to consult him regarding any symptoms that may develope. There will be no charge for such consultation and advice.
>
> The management also gives to guests the following low rates for examinations:
>
> | Examination of Sputum, | - | $1.50 |
> | " Urine, | - | $1.50 |
> | " " Blood, | - | $2.00 |
> | Physical Examination including Examination of Urine, | - | $2.50 |
>
> These charges are merely to cover the outlay for material used and at the same time gives the resident physician the advantage of arriving as closely as possible at a correct diagnosis of your case.
>
> We repeat again that guests must keep the physician constantly informed regarding their ailments in order to derive every benefit possible from the treatment. Medicines are provided to guests at cost price.
>
> There will be a charge made for medical services after 9 P. M.

Ladies were a new marketing focus with the construction of the Moorish-style Second Hotel. The hotel provided steam heat, indoor plumbing, and all the amenities a socialite from San Francisco or Los Angeles might require. Attendants were nurses under medical direction. A woman could arrive at the spring and take a "cure" for what ailed her—even if it were weight reduction—with discretion assured.

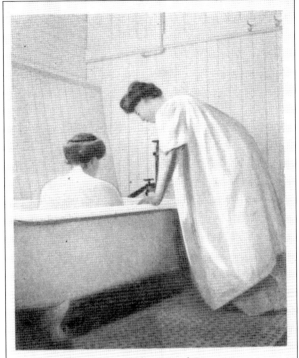

Baths are commodious, attendants expert

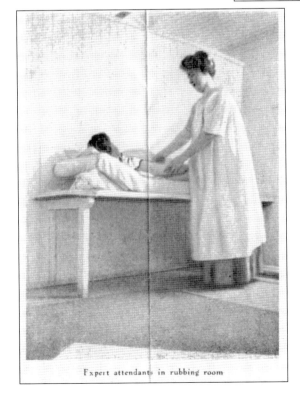

Expert attendants in rubbing room

According to a 1904 brochure, baths were an irresistible attraction to the feminine visitor, with "waters of lost youth" and the "baths of beauty," which continued to beckon the 20th-century woman. The waters "are the best remedy for rough skin and given any encouraging basis to work upon, will speedily turn out an epidermis as 'soft as velvet, as transparent as porcelain.'"

RATES

AMERICAN PLAN, ROOM AND SPLENDID MEALS INCLUDED.

Daily:
One person in room $ 6.00 to $ 9.00
Two persons in room 10.00 to 15.00

Weekly:
One person in room 36.00 to 54.00
Two persons in room 60.00 to 90.00

Monthly for Calendar Month:
One person in room 135.00 to 200.00
Two persons in room 255.00 to 385.00

Transient Meals in American Plan Dining Room:
Breakfast $1.00; Lunch $1.50; Dinner $2.00. On Sundays and holidays dinner served at noon.

EUROPEAN PLAN, ROOM ONLY

Cafeteria:
Excellent Meals Available in CAFETERIA, OPEN TO THE PUBLIC.

Daily:
One person in room $ 1.50 to $ 2.00
Extra persons in room, each 1.00

Weekly:
One person in room 9.00 to 12.00
Two persons in room 15.00 to 18.00

Monthly for Calendar Month:
One person in room 35.00 to 45.00
Two persons in room 60.00 to 72.00
Camp Ground privilege, per day50

Charges for service:
Hot Salt Bath, each $0.50
Blanket Sweat50
Peat (mud) Bath, each 1.00
Alcohol and other rubs, each 1.00
Massage, each 1.50
Massage in room, each 2.00
Examination by physician 1.50
Office or room call 3.00

Parking space free.
Garage storage per day 24 hours50
Garage storage per week 2.50

Our constant aim is to provide adequate, dependable and satisfactory service efficiently and economically.

The Manager will be glad to be of all possible assistance to you and he will appreciate your informing him of any and all cases in which our service is not completely satisfactory or suitable to your needs. Every employee in the organization is prepared to take your order or to cooperate in any way to give you prompt, satisfactory service.

YOU ARE WELCOME AND EXPECTED.

BYRON HOT SPRINGS HOTEL
Operated by
T. E. Farrow W. M. Sell, Jr.

Prices for services kept up with inflation by including fewer and fewer amenities after Lewis Mead died and the property was leased to management companies. This rate sheet from the late 1930s notes the end of free parking and a substantial increase in room rates. Medical treatment was no longer included in the cost of the room. No mention is made of railroad transportation.

There was still fun in the old Mud Bath Building after the glory days passed. This gentleman visitor in the 1960s mugs for the camera as he swings above the black sulphurous mud bath. No paying customers visit the springs now. In fact, no one dares dip into the bubbling mud bath for fear of what lies beneath. The "spa life" has not become fashionable yet again.

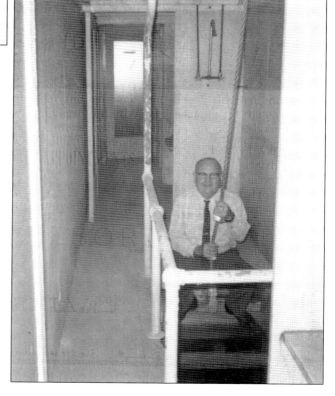

Three

The Second Hotel

The Second Hotel, built soon after a fire at a reported cost of $150,000, was situated on a small knoll directly across the square from the First Hotel. The striking Moorish-style hotel was a three-story, frame-stucco structure facing east. The broad verandas commanded a view of the San Joaquin Valley and extended across the entire front of the hotel and along two sides for a total length of 400 feet. The business offices, the doctor's office, the post office, and the telegraph and telephone stations opened from the foyer that extended the full width of the building. The dining room was in the north wing and housed the kitchen, cold storage, and pantry. Guest rooms were all outside rooms located on the second and third floors. Many were equipped with private baths of hot salt water piped in along with regular hot and cold water.

James Reid designed the hotel to combine many features of Spanish and Moorish architecture with the best features of American construction. Reid, a European-trained, Beaux-Arts architect and brother Meredith created the Reid Brothers architectural firm of San Francisco. Among their more well-known efforts were the Fairmont Hotel, the San Francisco Band Shell in Golden Gate Park, John D. Spreckels's residence and Daily Call Building in San Francisco, the Hotel del Coronado in Coronado, the Portland Oregonian Building, and the Grand Lake Theatre in Oakland.

With the advent of the automobile, people as far away as San Francisco, Palo Alto, Oakland, and Stockton spent weekends bathing; playing tennis, croquet, golf, billiards, and shuffleboard; horse riding; or relaxing in the gardens or on the verandas at the hot springs. Trains and buses brought people from all parts of the United States to enjoy the benefits of the waters. At about 5:00 a.m. on Thursday morning, July 18, 1912, fire broke out at the hotel and spread rapidly to all parts of the building, but the guests were warned in time to dress and escape. Although no one suffered injury, there was great loss of personal property. R. M. Briars, the manager of the resort at the time, suspected faulty wiring as the cause. Mead was disconsolate, but his new wife, Mae Sadler Mead, stated, "We'll build again!"

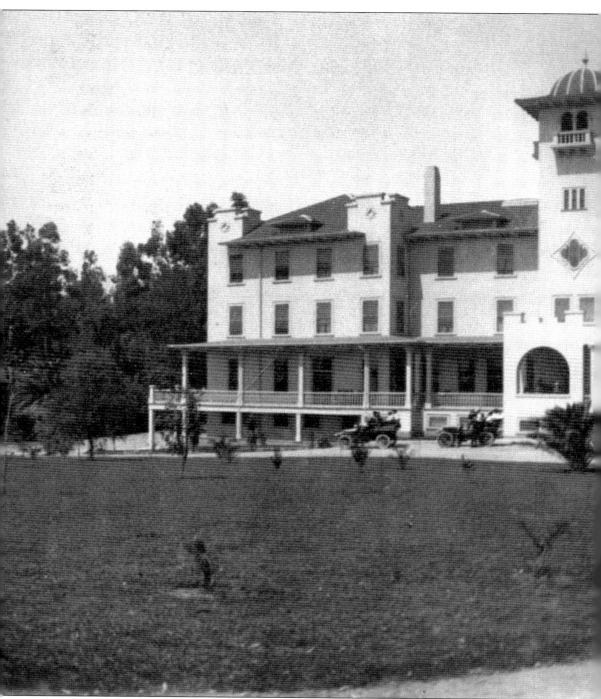

The Second Hotel, built soon after the wooden First Hotel was destroyed by fire in 1901, was situated facing east on a small knoll directly across the square from the First Hotel. It was a three-story, frame-stucco structure that reputedly cost $150,000. The broad veranda commanded a view of the San Joaquin Valley, extending 400 feet. The offices, the doctor's office, the post office, and the telegraph and telephone stations opened from the foyer extending the full width of the

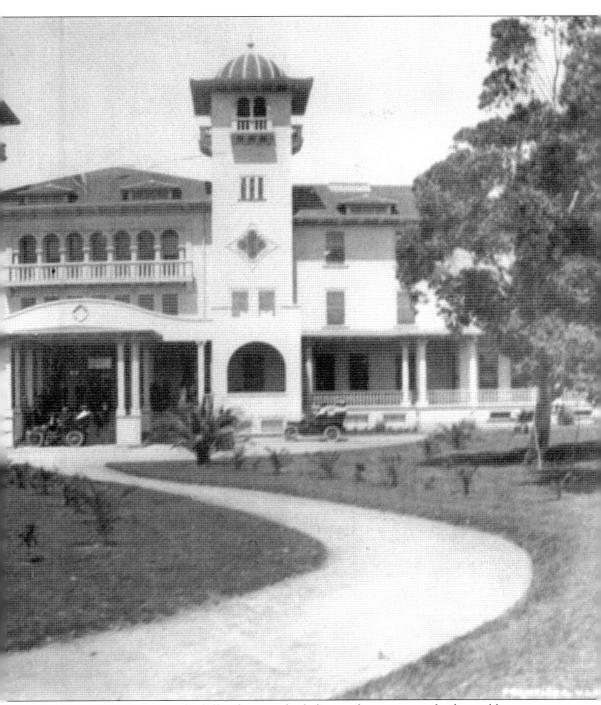

building. Adjoining were the billiard room, the ladies reading room, and other public rooms. The dining room in the north wing also housed the kitchen, cold storage, and the pantry. Guest rooms, all outside rooms, were on the second and third floors. Many were equipped with private baths with piped hot salt water as well as normal hot and cold water.

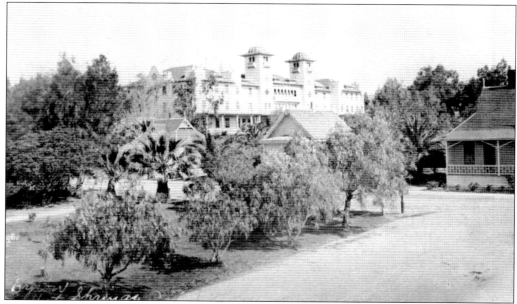

This original photograph, taken around 1903, features the new hotel and one of the original 1860s structures used to secure the land patent. The little outbuilding is now a private, rentable cottage. Adjacent to the cottage is the White Sulfur Spring, hidden in the trees. The recently planted flora has not gained the lush aspect it achieved in the next decade.

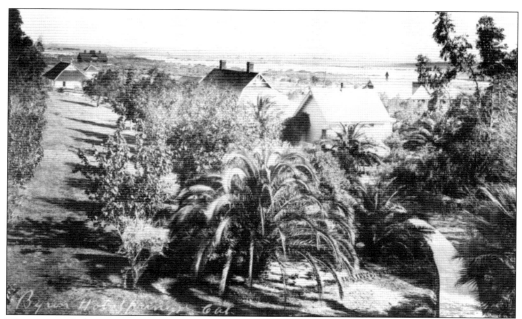

This original photograph, taken from the roof of the Moorish-style Second Hotel, features "lovers lane" bordered on each side by imported Indian pepper trees, now a common central valley ornamental tree. At the far end of the lane is the Salt Water Plunge. The other outbuildings are houses for the staff and support buildings.

This image is one of several used to market Byron Hot Springs at the Panama Pacific International Exhibition of 1915. This photograph was developed onto clear glass, mounted into an electric light box, and illuminated from the back. The new application of technology was impressive. The image was subsequently used for a postcard.

The Mead Cottage continued as the official residence of Blanche and Lewis Mead. The couple split their time between San Francisco and Byron. The trees obscuring the home and the Queen Anne turret are pomegranate trees known for their delicious red fruit. Pomegranate trees are now the community signature tree lining the Byron Highway on the western town approach.

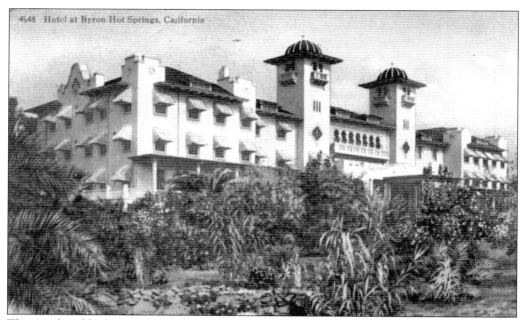

The new hotel had many features of Spanish and Moorish architecture combined with the best features of American construction. Its architect, James W. Reid, was a European-trained Beaux-Arts architect and partner in the Reid Brothers firm of San Francisco. Reid was particularly proud of this effort and replicated the style in many movie houses, most notably the Alhambra Theatre in San Francisco and the State Theatre in Monterey.

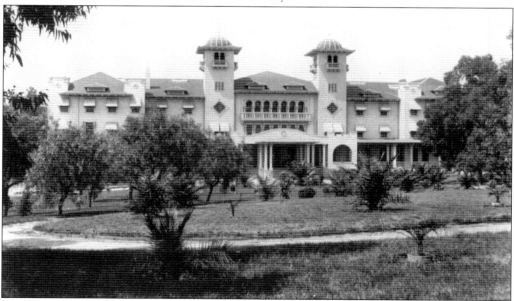

Day-to-day operation was under the new management of R. M. Briars, and the resort saw its greatest period of success under his watchful eye. Financial matters became more formalized as Byron Hot Springs Company incorporated on December 22, 1903. On the board of directors was Lewis Risdon Mead, Blanche D. Mead, Charles E. Parent, Sanford Bennett, and San Francisco mayor and governor of California Joseph "Sunny Jim" W. Rolph.

Both visitors and critics alike adored the new hotel. It was the most photographed and most commonly sent postcard from the springs of all time. With the advent of the automobile, people as far away as San Francisco, Palo Alto, Oakland, and Stockton could spend weekends bathing; playing tennis, croquet, golf, billiards, and shuffleboard; riding horses; or relaxing in the gardens or on verandas.

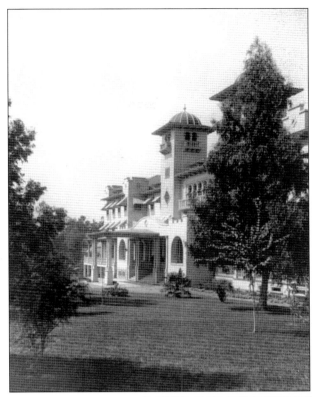

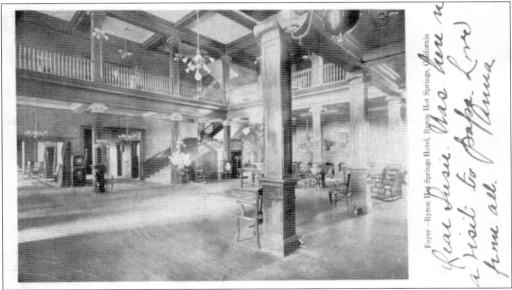

The interior of the new hotel had classic clear lines and paralleled, in most details, the lobby of James Reid's first achievement in California, the Hotel del Coronado. Early signs of the popular Arts and Crafts school of design can be seen here. Electric lights reminiscent of oil burning chandeliers illuminate every public area and room. The ubiquitous brass spittoon tells that it isn't too far out of the last century.

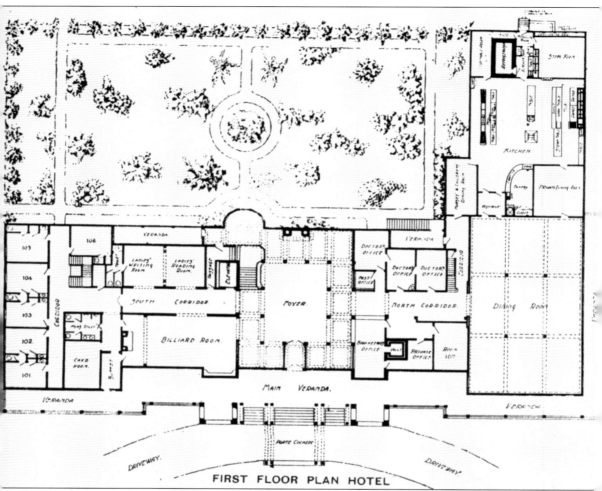

Fortunately, the original architectural drawings and blueprints still exist to provide building details and insights into cultural life at the turn of the 20th century. This first-floor plan shows a large billiard room and across from it two small ladies' writing and reading rooms. Ladies did not play billiards at the time. Dr. Louis Durant Mead, a recent medical school graduate, had his offices just to the right. The board meeting room, the U.S. Post Office, and private offices were close by. A balcony rang the entry for guests on the second floor to both "see" and "be seen." A fireplace cheered the room on the far right. Note the open foyer with airy, inviting hallways to the billiard room and ladies writing and reading rooms as well as the size of the vault. This hotel expected to make money.

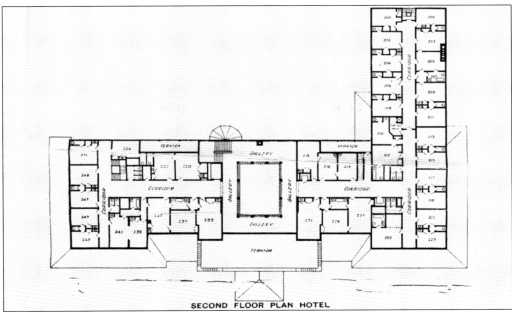

The floor plan of the hotel's second floor could easily be mistaken for a modern hotel of today. There were private bathrooms for every room and stairs and elevators made easy access for the invalid and the infirm as well as the able bodied. The only thing missing were the ice maker and the vending machine. It was of no matter as the maid would be along in a snap with water and ice.

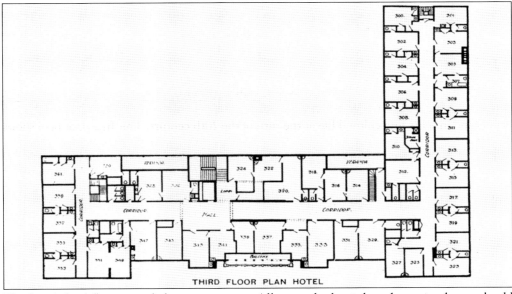

The hotel third floor provided more economy. All rooms had a sink and running hot and cold water. Some of them shared a toilet, and the showers were down the hall. Air conditioning had not been invented so an open window was essential in 110 degree, pre-air conditioned Byron in August. Never the less, one would find similar accommodations at the Reid-designed, luxurious Fairmont Hotel in San Francisco.

The opening of the hotel called for an all-out media blitz. The December 1902 issue of *Sunset: A Magazine of the Border* featured the wondrous Byron Hot Springs health resort and its world-class hotel. The Southern Pacific Railroad created and owned *Sunset Magazine* to promote train ticket sales and excursion packages. The railroad also owned the Hotel del Monte, but competition from Byron Hot Springs spurred friendly rivalry more than friction. Proprietor Lewis Mead installed in Byron anything that del Monte claimed in the press, if not sooner than its rival. The resort was featured prominently in many Southern Pacific publications. *The Road of a Thousand Wonders*, published by the railroad passenger department, featured the Coast Line and Sierra route from Los Angeles to Portland. The travel log described the passing scene by railroad car, noting only Byron Hot Springs as a major attraction between the San Francisco Bay area and Sacramento.

LOOKING THROUGH THE PALM GARDEN TOWARD THE HOTEL

Where Water is Life

BY JOHN C. KLEIN

MOTHER NATURE does indeed do all things well. When, cycles ago, she molded the land which it was destined should in time to come be known as California, she made provision as well for the healing of man (as yet unborn) and the consequent prolongation of life, as for that which should give him strength and health and the possibility of enjoying it.

Not only in climate and in soil, the equal of which may not be found on this continent, was this provided for but even "in the water under the earth" was contained that which might mend man's disease stricken body and make him well. It is in the life-giving springs of California which boil up to the earth's surface from far below that the nearest attainable results so eagerly desired and sought for in earlier days by the famed Ponce de Leon, may be found. From far Siskiyou in the north to the Mexican line in the south and from the shores of the Pacific to where the great Sierras mark the eastern limitations of the state, here and there, are to be found springs of healing waters which might, not inaptly, be termed Nature's medicine chests.

We, of the Pacific coast, know better of the truly remarkable benefits which may be obtained by making use of these opportunities, placed at our disposal by Nature than do those living in more distant parts of the United States, but month by month and year by year the fame of California's medicinal springs are becoming more widespread, not in our own land alone, but beyond the seas.

This three-page article used many of the images of the buildings and grounds later used in postcards, brochures, and marketing materials. The photographs appear first in *Sunset Magazine*. The author, John Klein, used all the exaggeration and hyperbole expected of a writer paid by the word and motivated to promote ticket sales. The author writes, "In the luxurious drawing room of a Pullman car you may take your ease and reset content until, after you arrive at the railroad station of Byron [Hot Springs] and a few minutes later are standing in the lobby of the new hotel." He goes on to extol the curative properties, the most equitable climate, and medical supervision of the highest caliber at the springs. Comparisons are made to Arkansas Hot Springs, Virginia White Sulphur Springs, and the springs in Mount Clemens, Michigan. Perhaps not all is exaggeration. Pres. Franklin Roosevelt gave all credit for his ability to walk once more to the therapeutic water effects of Warm Springs in Georgia.

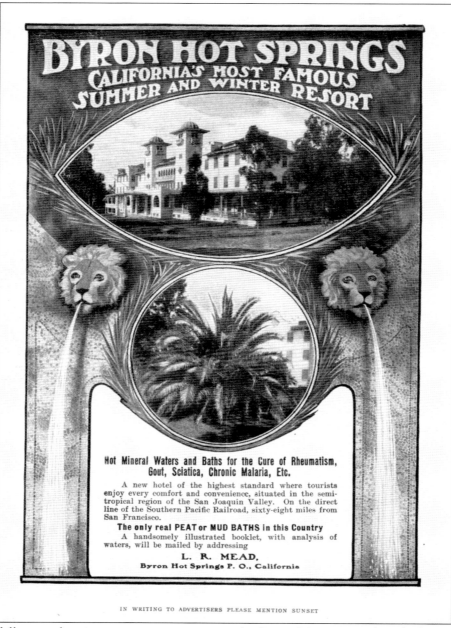

This full-page advertisement was a constant in the *Sunset Magazine*. It described an exotic destination, Byron, with modern hotel conveniences. Palm trees and lush semi-tropical gardens were only 68 miles away to another world. Water flowed from fountains. And Byron was no longer marketed as a sanitarium for invalids. The term "sanitarium" was dropped from all brochures. Rather, Byron became a modern, 20th-century resort, not a hospital. There was something for everyone—recreation, health, and other amusements. Alcohol and gambling were available too, but they were discreet options. Hydropathy became a spa treatment. Years before, individuals traveled to Calistoga spas to sit in peat moss purchased in bags from garden suppliers, but at that point all could come to Byron for the real delta product.

Sunset soon developed into the leading magazine of the West, employing artists and writers who soon would make their names in 20th-century American art history. J. Maynard Dixon (1875–1946) illustrated this cover dated July 1904. Dixon was a pivotal connection between late 19th-century and contemporary American art. His work opened the way for the "sparse rock," "cloud," and "desertscape" vocabulary developed by a number of artists, including Georgia O'Keeffe.

Advertisements for the Hotel del Coronado and Byron Hot Springs often appeared side by side. This ad is typical of smaller magazines of the era. John D. Spreckels, of C&H Hawaiian Sugar Company fame, owned the Hotel del Coronado. Spreckels was so impressed by its architect, James Reid, that he became Spreckels's exclusive architect for all projects from sugar mills to personal Nob Hill residences.

Lewis Mead's considerable business and political connections secured for the springs a U.S. Post Office designation, which opened on August 17, 1889. This hand-franked dead letter office notice, dated July 24, 1895, informs the sender of the "evening mail" that the recipient is no longer at the Byron Hot Springs address. The writing is in Lewis Mead's own hand, as he was postmaster of the station.

This hand-franked 1911 postcard sent from the springs proclaims the beauty of the Moorish-style Second Hotel once again. Collectors seek the Byron Hot Springs Post Office frank as the office closed on December 31, 1930. Original photographic postcards are even more coveted.

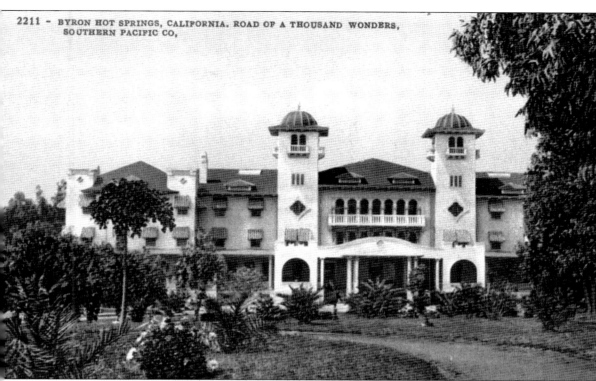

2211 - BYRON HOT SPRINGS, CALIFORNIA. ROAD OF A THOUSAND WONDERS, SOUTHERN PACIFIC CO,

The beautiful Second Hotel lasted just a decade before it too was consumed by fire. At about 5:00 a.m. Thursday morning, July 18, 1912, fire broke out in the hotel and spread rapidly to all parts of the building. Guests were warned in time to dress and escape. Although no one suffered injury, there was great loss of personal property. Word passed quickly throughout the Byron community of the great fire. Faulty electrical wiring was suspected as the cause. The existing water system had insufficient water and pressure to stop the conflagration, and the building was underinsured. Mead did not know what steps to take next.

Lewis Mead, 65, was distraught at the loss of the Second Hotel, but despair never crossed the mind of Mae, his youthful wife, who said, "No! We'll rebuild!" James Reid was called and plans were made to build a new brick fireproof hotel at a different location on the grounds. The remains of the destroyed hotel were left in place as "romantic ruins," an image that was popular at the time.

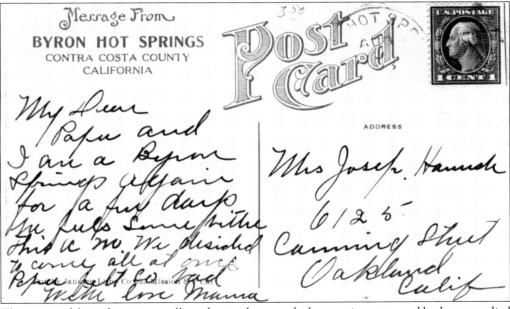

This postcard from the springs still emphasizes how much the curative water and baths were relied upon for relief. Here someone (presumably mama) writes, "Papa and I are a[t] Byron Springs again for a few days. He feels some[what] better this a [sic] mo[nth]. We decided to come all at once [.] Papa felt so bad. With love Mama."

This cute cottage served as an original improvement required to secure the land patent, then as an outbuilding, and finally as an intimate bungalow for guests requiring privacy. It may have been in a bungalow such as this that Clark Gable wooed his fifth and last wife, Joan Spreckels. She was the ex-wife of John D. Spreckels's nephew John. It was a small world then; everyone knew or was related to one another.

Camping at Byron Hot Springs for relaxation was common even before Mead founded his hot springs. Camping in canvas tents was still an inexpensive option for guests who preferred the outdoors or found the hotel rate too steep. These happy visitors hope their friends will join them.

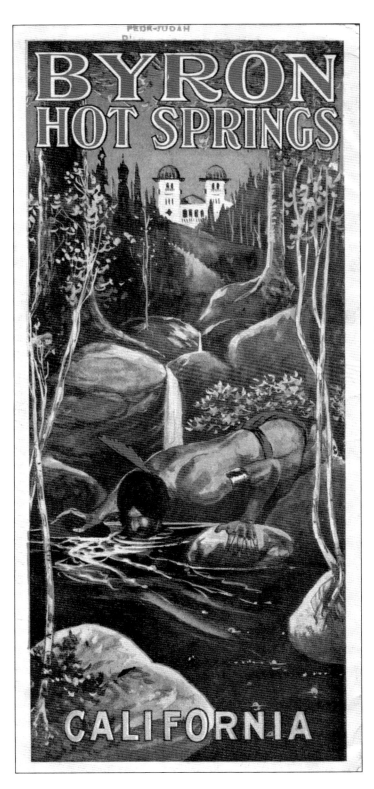

This 1902 brochure describes the resort as, "An Oasis, not of the desert but of the hills, an emerald set amid slopes, now ruddy with ripened grain, now pale with the golden gleam of stubble, now dark with the up-plowed earth or in the springtime, glistening with the tender wheat while the places of shallower soil are enameled with the gold and blue of California poppies—cups of gold—and stately lupines. All about the vale in which nestles the Oasis are the rounded hills like billows, growing smother as they travel from their source, serrated Mount Diablo, purple in its valleys, green on its slopes and ridges, looking over the shimmering river and down the valley of the San Joaquin. Back of Diablo lies Oakland, the bay and San Francisco a scant forty miles away as the biplane flies, fifty odd by motorcar and sixty odd by rail."

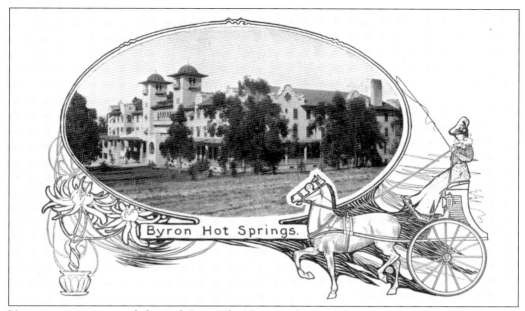

Victorian, romantic, and classical, Diana the Huntress featured the romance of Byron Hot Springs in this early 1900 Contra Costa County Chamber of Commerce brochure. East County boasted fruits and vegetables, the delta, and Byron Hot Springs. The resort was still the essential boast until the major subdivision construction and population boom of the 1990s.

The success at the springs also came with sorrow as proprietor Lewis Mead's wife of 32 years, Blanche, passed away at the springs on the day after Christmas 1905. She had not felt strong enough to journey from San Francisco but recruited her strength to arrive for Christmas. Her son, Dr. Louis Durant Mead, attended to her and signed the death certificate.

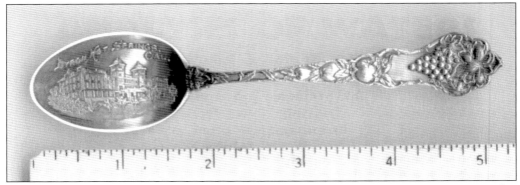

Collectables such as spoons, ink blotters, and similar souvenirs were part of any vacation. This teaspoon and a smaller demitasse spoon were popular souvenirs. In the spoon bowl, the Moorish Second Hotel in relief can be seen. The camas leaves and grapes are stock manufacture items. Earlier spoons featured the image of a Native American instead of grape clusters.

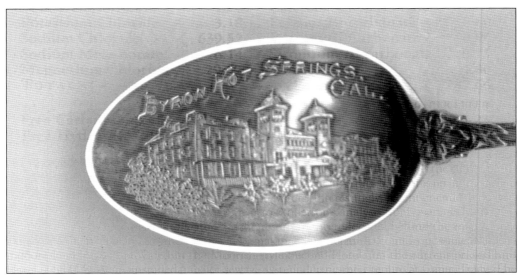

This close-up of the teaspoon bowl once again features the Second Hotel. One consumed the mineral waters by the tin dipper in earlier years with often dramatic effect. Perhaps the modern visitor learned to take his or her medicine with a little more temperance—by the spoonful.

Printed daily menus are commonplace even in today's fashionable restaurants. This beverage menu shows a range of wines, champagnes, soda, alcoholic beer, non-alcoholic beer, and mineral waters. Most of the beverages are still available today. European and California wines are featured. Note the excellent Napa Valley selection from Schramsberg Vineyard. Cresta Blanca Vineyard represents Livermore wines, always known for their excellent Riesling. This menu was part of the collection maintained by the famous Old Poodle Dog Restaurant in San Francisco. Like many establishments today, celebrities financially backed favored chefs as silent partners. The Old Poodle Dog had the Spreckels family backing. John D. Spreckels was the brother-in-law to Big Alma Spreckels; James Reid was their preferred family architect; Reid built the Cliff House for Adolph Sutro; John Tait bought the Cliff House; and everyone knew Lewis Mead. They all ate, socialized, and played together at Byron Hot Springs.

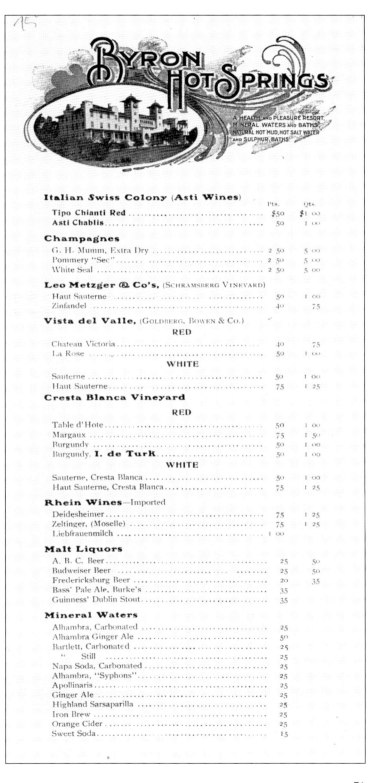

Byron Hot Springs

A HEALTH AND PLEASURE RESORT, MINERAL WATERS AND BATHS, NATURAL HOT MUD, HOT SALT WATER AND SULPHUR BATHS

	Pts.	Qts.
Italian Swiss Colony (Asti Wines)		
Tipo Chianti Red	$50	$1.00
Asti Chablis	50	1.00
Champagnes		
G. H. Mumm, Extra Dry	2.50	5.00
Pommery "Sec"	2.50	5.00
White Seal	2.50	5.00
Leo Metzger & Co's, (Schramsberg Vineyard)		
Haut Sauterne	50	1.00
Zinfandel	40	75
Vista del Valle, (Goldberg, Bowen & Co.)		
RED		
Chateau Victoria	40	75
La Rose	50	1.00
WHITE		
Sauterne	50	1.00
Haut Sauterne	75	1.25
Cresta Blanca Vineyard		
RED		
Table d'Hote	50	1.00
Margaux	75	1.50
Burgundy	50	1.00
Burgundy, **I. de Turk**	50	1.00
WHITE		
Sauterne, Cresta Blanca	50	1.00
Haut Sauterne, Cresta Blanca	75	1.25
Rhein Wines—Imported		
Deidesheimer	75	1.25
Zeltinger, (Moselle)	75	1.25
Liebfrauenmilch	1.00	
Malt Liquors		
A. B. C. Beer	25	50
Budweiser Beer	25	50
Fredericksburg Beer	20	35
Bass' Pale Ale, Burke's	35	
Guinness' Dublin Stout	35	
Mineral Waters		
Alhambra, Carbonated	25	
Alhambra Ginger Ale	50	
Bartlett, Carbonated	25	
" Still	25	
Napa Soda, Carbonated	25	
Alhambra, "Syphons"	25	
Apollinaris	25	
Ginger Ale	25	
Highland Sarsaparilla	25	
Iron Brew	25	
Orange Cider	25	
Sweet Soda	15	

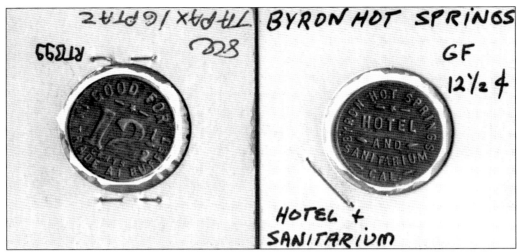

Part of good advertising was the use of "wooden nickels," or tokens, usually with an exchange value for goods or services at the establishment advertised. These tokens for Byron Hot Springs had the equivalent value of 12.5¢, or one "bit" at the buffet. In reality, one bit was good for one shot of whisky.

A person could trade in a one-bit token at the buffet or walk over to the bar and ask William "Cocktail Bill" Boothby to mix one of his famous beverages from his well-thumbed *World Drinks and How to Mix Them*. He would show how to put the fizz back in flat beer or recreate the lost gold rush recipe for Pisco Punch.

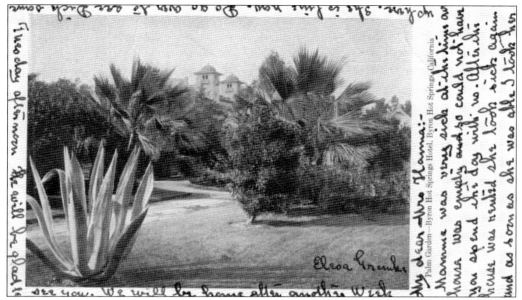

All was not happiness and pleasure at the springs. This postcard from 1908 tells the tale of sickness at Christmas, renting of the home, and retreat to Byron Hot Springs in search of a cure. Rarely is a postcard read that does not have some upbeat ending. In this case, friends are urged to visit.

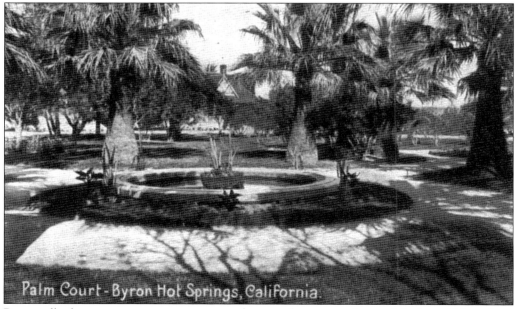

Repeatedly there are newspaper accounts and personal correspondence of the beautiful gardens, particularly the Palm Court. How refreshing it must have been to find the cool, spring-watered gardens after traveling by automobile, horse, or train through interminable dry wheat fields and alkali flats.

Sadler-Mead Nuptials Will Be Held in Alameda Today

MISS MAE SADLER, SOCIETY GIRL OF ALAMEDA, WHO WILL BE MARRIED THIS EVENING TO LOUIS RISDON MEAD, OWNER OF BYRON SPRINGS. (Genthe photo)

Lewis Mead cared not to stay a widower for long. On June 20, 1907, Mead married Mae Sadler of Alameda. Young Miss Sadler was touring Europe when the 1906 earthquake and fire destroyed San Francisco. It was common for young, San Franciscan women of means to travel Europe to "finish" their education before settling down. Mae cut her travel short and hurried home. It is not known how Lewis and Mae met; however, Mae's father was a businessman. He and Mead may also have been brother Masonic Lodge members in Oakland, where Mead helped found the Brooklyn Lodge. Lewis and Mae were a spring/winter romance as Mead was 60 years of age and Miss Sadler, although of an unreported age at her marriage, was surely under 25. The two were marketing dynamite. He was an affable clubman with the gift and financial resources for promotion. She was youthful, good-looking, and energetic. This photograph was taken on their wedding day.

The new Mrs. Mead assumed her social position and began work immediately. This 1915 photograph shows Mae as the youngest woman member of the Panama Pacific International Exhibition "Woman's Board." She capably served as chairwoman of the Byron Red Cross chapter. Later she served as the 1929 president of the San Francisco Opera Woman's Board.

Mae appeared frequently as a society favorite in the *San Francisco Call* and the *San Francisco Chronicle* society pages, and her trips to Alameda to visit family were noted. Even her departure and return from the Mead's residence at Byron Hot Springs received society notice. While in the city, she and Lewis made their new residence at the recently reopened Fairmont Hotel.

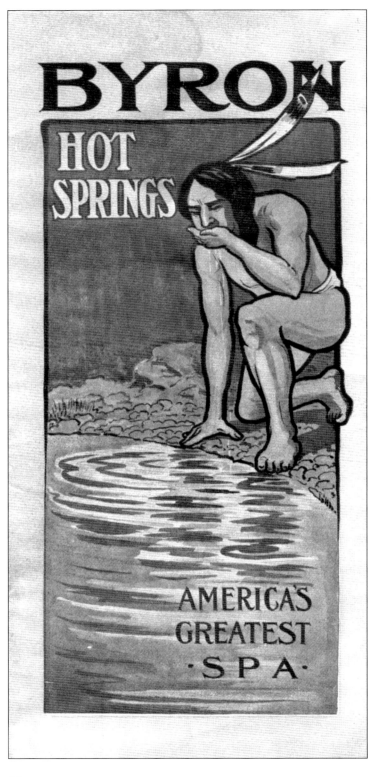

This brochure dates from 1905 and was available by application to the proprietor. Legend has it that Lewis Mead was inspired to turn the aborted salt manufacturing company into a health resort by observing the local Native Americans drinking and bathing in the springs. This is certainly inspired marketing as Westerners were entranced by the romantic image of the Native American and of the West as the true American frontier closed. Inside America's greatest spa, one is reminded of the "distinctive features of Byron Hot Springs: The only genuine, naturally medicated Peat Baths in America, Waters more efficacious and prompt in action than those of Carlsbad, yet free from the slightest unpleasantness, the only hotel in the world where you can go from your room to a hot mineral spring bath in the same building, and [will] positively and permanently cure of any form of rheumatism, stomach or nervous disorder, if your case is curable; and will ameliorate any case, however serious."

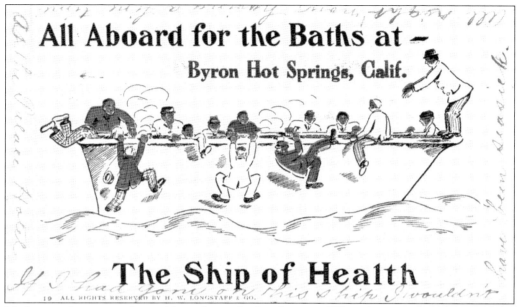

Marketing the springs focused heavily on the hotel image. When frequent fires destroyed the advertising centerpiece, stock postcards with the name Byron Hot Springs had come into favor. "The Ship of Health" was a common metaphor used by many health and hot spring resorts across the nation.

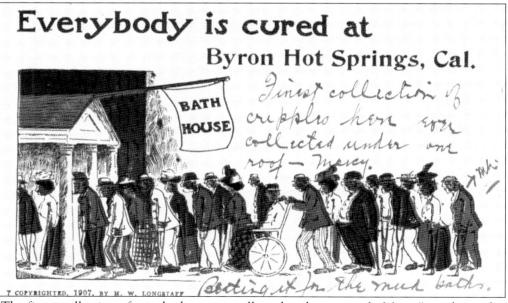

"The finest collection of cripples here ever collected under one roof—Mercy," proclaims this visitor. The Arkansas Hot Springs and others also used this stock 1907 postcard. This one is overprinted with "Byron Hot Springs."

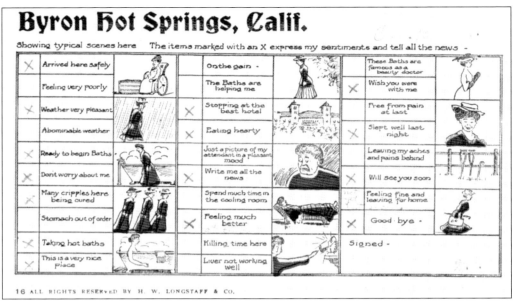

How does a person feel? He or she just checks the box and mails this out. Each image is a miniature of available, full-size postcards. One image in the center is unique, with a line drawing of the Moorish-style Second Hotel. All the positive marketing points are checked. It must have been a good visit.

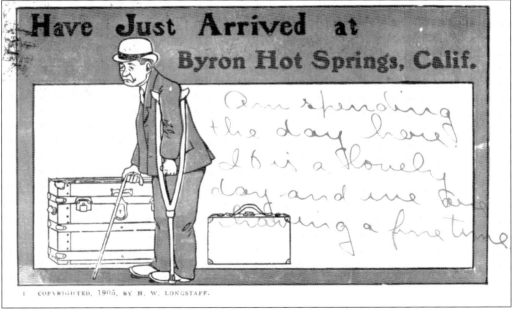

The message on this postcard contradicts the sad-faced invalid on the card. This one-day visitor to the springs reports, "Am spending the day here. It is a lovely day and we are having a fine time."

Four

The Third Hotel

A new hotel, again designed by Mead's great friend James Reid, opened for business by late 1914. Its ribbon cutting coincided with the opening of the Panama Pacific International Exposition in San Francisco. This hotel had a new mistress, as Lewis's first wife, Blanche, had died at the springs on December 26, 1905. Two years later, Mead remarried and his new wife, Mae Sadler Mead, was central to the rebuilding of yet another Byron Hot Springs hotel. Theirs was a winter/spring romance, as the youthful Mae was in her early 20s and Lewis was a prosperous mid-60s San Francisco clubman.

The Third Hotel is a four-story, fireproof, brick and concrete structure built for an estimated $150,000. It exists still today. A new corporation, the Associated Pipe Company, was created to develop a new pumping station on the San Joaquin River two miles away to supply fire protection. Pipes were laid and water pumped to a reservoir on a hill behind the hotel and cottages. Water was released to fire hydrants placed adjacent to the structures. A depot was constructed at the nearby methane gas wells, originally exploited in 1889, for heating and lighting the entire resort. Fresh water for domestic purposes was piped from springs on site to a tank house near the tennis courts.

Lewis Risdon Mead died of bronchial pneumonia on June 12, 1916. His widow, Mae Sadler Mead, took over management of the resort and constructed a memorial building to her late husband. Again, with James Reid as architect, the Liver and Kidney Spring was enclosed within a brick building with an Alaskan marble and inlaid stone interior. The walls were decorated with scenes of mountains, valleys, and streams.

James Reid and Mae Sadler Mead subsequently married in New York in 1920. Upon their return to California, the couple resided at the Fairmont Hotel in San Francisco and at Byron Hot Springs. The newly remarried Mae Reid continued as president of the Byron Hot Springs Corporation.

A new hotel and another new beginning inspired Lewis Mead to create heraldry and a motto for the Byron Hot Springs experience: "Crede Byron." Two horses stand aside a three-striped shield crowned with a mermaid. The three stripes could easily refer to the three generations of Meads involved at that point with the resort.

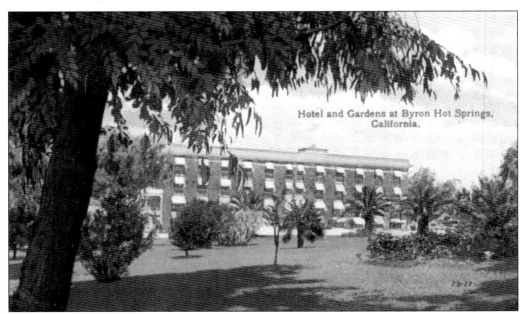

Another new hotel was again designed by James Reid and opened for business in late 1914. Its reopening coincided with the ribbon cutting of the Panama Pacific International Exposition in San Francisco. The Third Hotel is a four-story, fireproof, brick and concrete structure built for about $150,000. It still exists today.

James Reid designed the Third Hotel to be reminiscent of the Fairmont Hotel in San Francisco without the Beaux-Arts flourishes. Reid learned a lot about reinforced concrete from fellow architect Julia Morgan, who consulted on the rebuilding of the Fairmont after its destruction during the 1906 earthquake and fire.

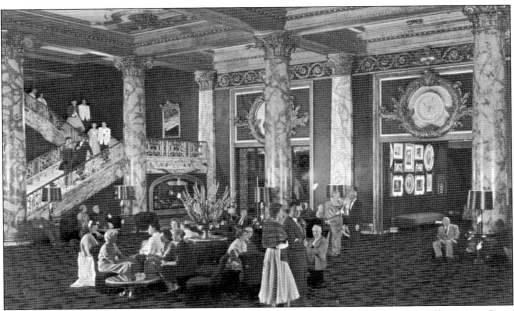

The interior of the Fairmont Hotel was luxurious, as this postcard from the 1950s illustrates. Strip away the Corinthian columns, marble columns, and coffered ceiling and the clean modern lines stand out. Openness and accessibility form Reid's signature. In this manner, Reid is the early proponent of the Chicago school of Modern Architecture in California.

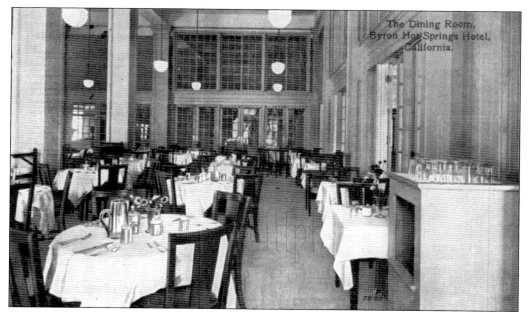

Compare this interior photograph of the Third Hotel dining room to the lobby of the Fairmont. Strip away the elaborate cornices and gingerbread. The same style is found but in a more modest manifestation. The functionality of the Arts and Crafts movement has its influence here.

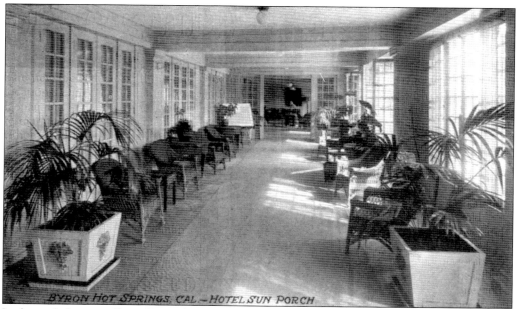

Lathe and plaster walls and French doors add air and light to a lower-level sunroom in the brick Third Hotel. Gone are flammable wooden construction elements. This building is reinforced concrete with a brick facade. Potted plants and palms carry the exotic, semitropical garden theme indoors.

New advertising accompanied the new hotel. Mae Mead is the model admiring the lush landscape now fully mature along the Palm Court. Mae was a stylish, modern woman of the mid-1910s. Note she wears slacks and a tunic with sensible shoes for the country—the equivalent of "resort casual" today.

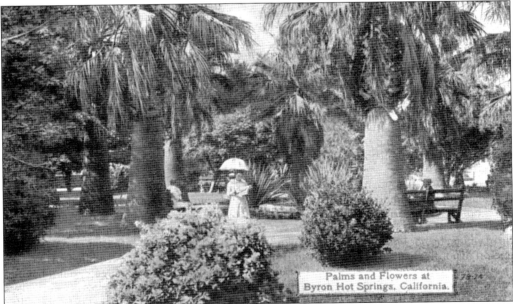

This photograph features a model carrying a sun-protective parasol at the Palm Court. This may be Dr. Louis Mead's wife, Charlotte. With a careful eye, proprietor Lewis Mead can be seen wearing a hat and sitting on a bench to her left. An unidentified visitor with her back to the camera sits to her right.

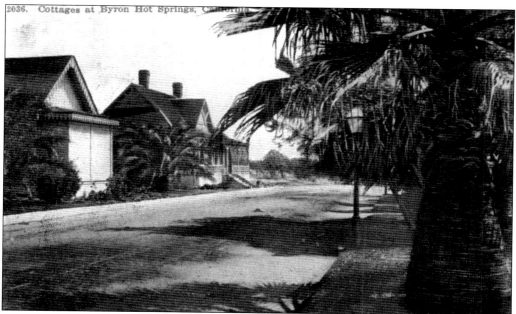

The cottages sitting on the corners of the Palm Court were placed strategically around the original drinking-water spring. Mead filled in the spring with good topsoil for a garden in the mid-1880s, using the drinking-water spring as the irrigation and fountain in the center. Cottages ensured privacy for both the ill and the celebrity away from inquiring eyes.

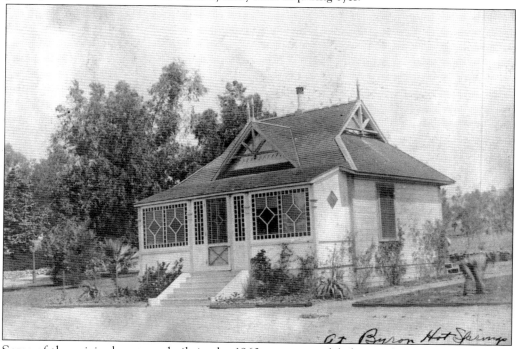

Some of the original cottages built in the 1860s were remodeled several times over the years. Note the cross-braced eaves added to replicate the roof style of the First Hotel. This little cottage features a beautiful stained glass enclosed porch so popular as a sunroom for invalids.

The Panama Pacific International Exhibition attracted visitors from around the world. Many came to see the exhibition and stayed for weeks or months to see California and the West. Byron Hot Springs expanded its advertising to this Los Angeles-based publication targeted at steamship passengers.

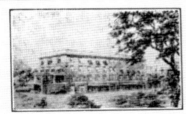

This advertisement in the *Ocean Wireless News* featured an architectural rendering of what the new hotel would look like. Much was made of the inaccessibility of the spas at Carlsbad, Germany, as Europe was at war. World War I started in August 1914 and spas on the continent were closed.

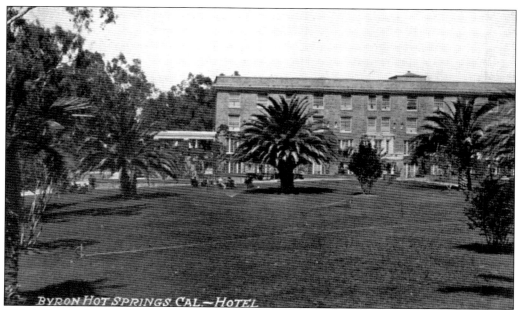

Third Hotel, the final one built at the springs, was a marvel of modern construction and mechanization. It claimed to be fireproof and it has proved to be such for almost a century. A water-pumping station was built on the river two miles away and pumped to a reservoir on a hill behind the hotel and cottages and then released to strategically placed fire hydrants.

C No. 364	BYRON HOT SPRINGS, CAL., March 31, 1917 191__
	PLEASE TAKE NOTICE--OUR CORRECT ADDRESS IS BYRON HOT SPRINGS P. O., CAL.

~~C. A. Read,~~ J.W. Reid,
105 Montgomery Street, San Francisco, Cal.

To Byron Hot Springs, Inc., Dr. $20

	Water Account for February, 1917,	40	00
	Water Account for March, 1917,	40	00
		80	00

APR 11 1917 BYRON HOT SPRINGS

Lewis Mead's young friend James Reid was a frequent visitor to the springs. Happily, this invoice for water for February and March 1917 has survived. Drinking water at the various mineral springs had been included in the hotel cost to the visitor heretofore. Is there a change in policy or is "water" a euphemism for something else?

Friends of the Sadler and Mead families pose in front of the Third Hotel. Note how a motorized jitney to meet visitors at the train depot and deliver them directly to their destination has replaced the horse-drawn estate wagon. Careful inspection of the top side of the jitney reveals the words, "Byron Hot Springs."

The heraldic symbol for "Crede Byron" appeared on letterhead, brochures, and all restaurant china. This china soup bowl is one of the few plates remaining from the dining room service. Bottle collectors on the site have found pot shards of cream pitchers, cups, and saucers for years. (Compliments of the Sadler/York family.)

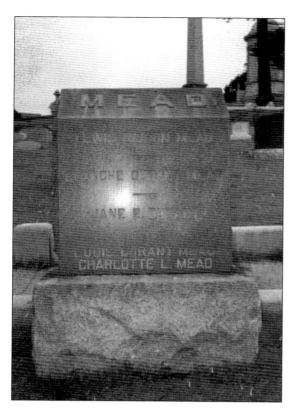

Lewis Risdon Mead, 69, died of bronchial pneumonia on June 13, 1918, exactly two years to the day following his son's sudden death. Lewis's widow, Mae, was appointed executor of her late husband's estate and assumed the active management of the resort. She and her daughter-in-law, Charlotte Mead, inherited all financial interest in the property. This is the family grave marker in Oakland.

Tragedy struck the family as Dr. Louis Durant Mead, the proprietor's son, was stricken with mental illness just as he sought active duty with the U.S. Army abroad. He was incarcerated privately at the Livermore Sanitarium and then at the Agnews State Insane Asylum in San Jose. He died of "softening of the brain" on June 13, 1916, leaving his wife, Charlotte, and their daughter as heirs.

Five

SOCIETY AT PLAY

The socially prominent Reids began their new life together in style. Mae Reid started her involvement with the San Francisco Opera, becoming an active member and in becoming president in 1929 of what would become the board of directors. She continued her clubwoman and social interests with memberships in the exclusive women-only Francesca Club, the Hillsboro Country Club, and other philanthropic organizations. The Mead Cottage at Byron Hot Springs continued as the couple's private country residence. Contemporary accounts recall the timed entrance and the sound of Mae's taffeta dress as she descended the marble staircase into the hotel dining room.

Then, in 1919, a management lease of Byron Hot Springs passed to John Tait, a well-known San Francisco restauranteur, under the auspices of the Byron Hot Springs Resort. Tait was the Harry Denton of his day and owned a series of restaurants in San Francisco and the East Bay known variously as Tait's at the Beach, Tait's Café, and the Cliff House. There is still a Tait's at San Francisco's Fishermen's Wharf, although the new owners probably have no idea of the name's significance. John Tait is perhaps best known today as the proprietor of the San Francisco establishment where Rudolf Valentino, of silent film fame, was discovered while employed as a dancer.

John Tait and his managers quickly turned the resort into a mecca for Hollywood stars and San Francisco socialites. Golf was the rage and the modest nine-hole course was expanded to 18 holes. The San Francisco Seals used the resort for spring training, rest, and relaxation. Famed baseball pitcher "Lefty" O'Doul claimed the therapeutic effects of the peat mud baths allowed him to go extra innings. Clark Gable wooed the Spreckels divorcée, Joan, who would become his fifth wife, at the springs. Fatty Arbuckle, Francis X. Bushman, and other stars found their way to the resort. Prohibition liquor and gambling raids were a bane to San Francisco public establishments but not so in Byron. Empty, brown Joseph Kennedy–brand whisky bottles with the Kennedy name pressed in the glass, dating from Prohibition, could be found on the site. It appeared one could both drink alcohol and seek the hangover cure at the same spa.

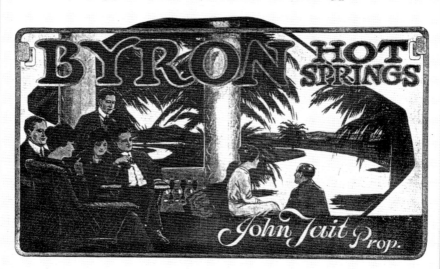

The Roaring Twenties arrived at Byron Hot Springs in great style. This full-page advertisement from the *Byron Times*, "the Monarch of the Weeklies," was used throughout the West to usher in new management and good times. John Tait, the famous San Francisco restauranteur, leased the springs from widow owners Mae Mead and her daughter-in-law, Charlotte Mead, in 1919. Mae was assuaging her grief with travel to the East Coast. Tait and his corporate investors spent a reputed $250,000 on improvements to the resort. A resident doctor was still on staff, but the new marketing emphasis was on resort qualities, not the sanitarium. All recreations were improved, including a new wooden swimming pool and grass greens on the nine-hole golf course. Tait used name cache to attract the younger, fast set with media darlings from Hollywood. Prohibition hooch never tasted as good as it did from the Byron Hot Springs Resort.

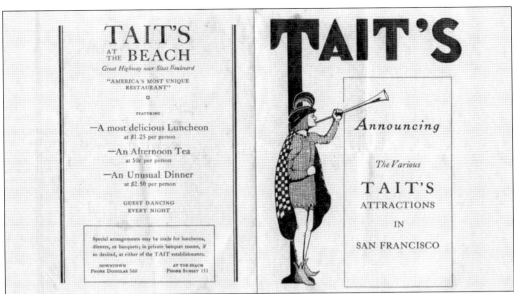

John Tait had restaurants throughout San Francisco. His famous Tait's at the Beach was located near what is now Sloat Boulevard at the Pacific Coast Highway and beyond public transportation lines at the time. The well-heeled arrived in their chauffeured cars for jazz, dining, and dancing. Tait subsequently bought the Cliff House from Adolph Sutro to create another dining destination. Tait's Café near the Orpheum Theatre was a favorite of the theatre crowd.

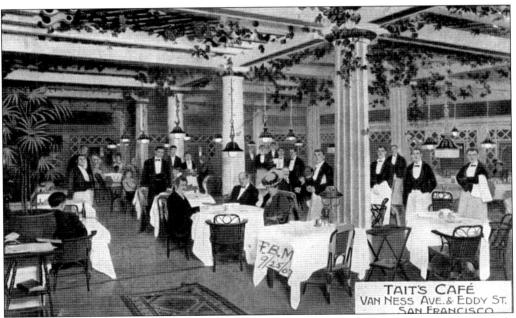

The interior of Tait's Café at Van Ness Avenue and Eddy Street, San Francisco, looked strikingly similar to the dining room design and decor of the latest Tait business venture at Byron. The Meads and James Reid must have known Tait well, at least by reputation. An early Tait-Zinkand Café was located in the Spreckels Call Building in which Byron Hot Springs had its San Francisco offices.

John Tait was the Harry Denton of San Francisco in those days. Contemporary newspaper accounts hail his promotional genius by claiming Tait to be "the man who discovered salt water in the ocean and pure air on the mountain top." Rudolph Valentino was discovered at Tait's, where he danced for hire. Rita Hayworth and her brother danced at Tait's before Rita became a Hollywood star. Tait cultivated these relationships and used them to promote his ventures.

Everything was up-to-date and modern. Brochures emphasized people rather than architecture in their design. Stylish and sophisticated people dined or recreated on the grounds. The beautiful Reid-designed building continued to present a showplace, but it became a backdrop and stage for good times. Beautiful Mae Mead regularly staged her entrance at the dinner hour down the hotel's marble interior staircase.

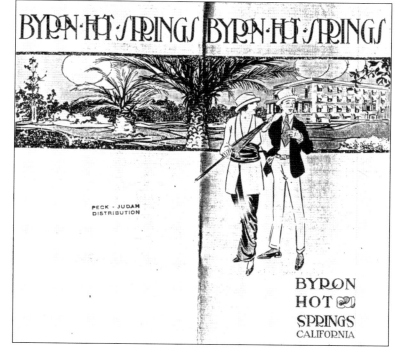

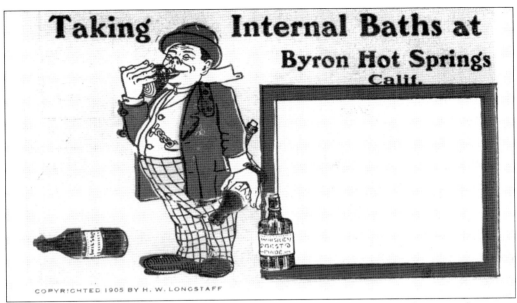

There is more to hydrotherapy than drinking mineral water, and this stock postcard suggests an alternative. Famous "Cocktail" Bill Boothby began his "mixologist" career in Byron after leaving the vaudeville stage. He subsequently worked at the top establishments in San Francisco as every man's favorite barkeep. His book, *Cocktails of the World*, was the standard recipe book for four decades.

The sender of this postcard certainly enjoyed the "internal waters." She writes, "People not one here I ever saw before but we all seem to be friends and have lots of fun at the springs in the mornings [.] One man told me this morning I had quite a jag on. I must not drink so hard and brought back a pitcher full [of mineral water] and they laughed at me rushing to the growler [restroom] feeling better."

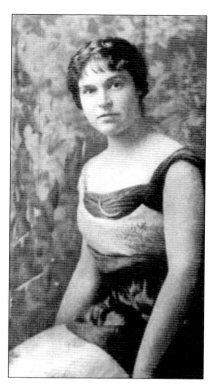

This is a 1914 photograph of Mae Mead in her role as Contra Costa County chairwoman of the Panama Pacific International Exhibition Woman's Board. She was a very attractive, wealthy, young widow just six years after this image was taken. Her qualities were not lost on Lewis Mead's young best friend, architect James Reid. Mae and Reid married in New York City in 1920.

James Reid was a European-trained Beaux-Arts architect who had a prolific career spanning four decades. He first came to the attention of John D. Spreckels when Spreckels acquired the Reid-designed Hotel del Coronado. Reid subsequently designed everything Spreckels built, including the Call newspaper building, sugar mills, and his personal residence. Reid's architecture exemplifies the Victorian San Francisco destroyed in the 1906 earthquake and fire.

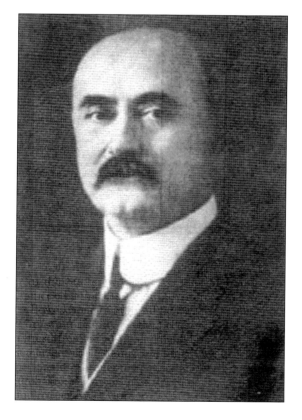

Peck-Judah Company, Inc. was the premier travel service of its day. Excursions of every kind, using every form of transportation, were secured at their offices. Coincidentally, the San Francisco offices of Byron Hot Springs happened to be in the same building as Peck-Judah.

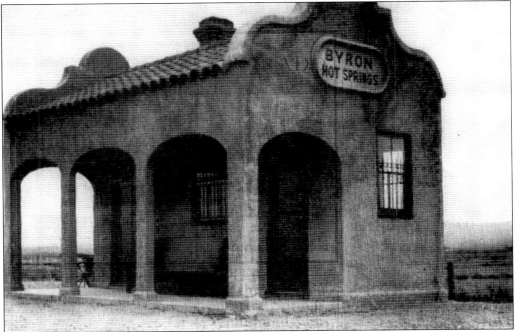

Travel became even easier when the Southern Pacific Railroad added a Byron Hot Springs depot stop to their regular line. This tile and stucco building complements the Moorish-style Second Hotel design. Trains stopped three times eastbound and four times westbound every day at this depot to handle the number of guests.

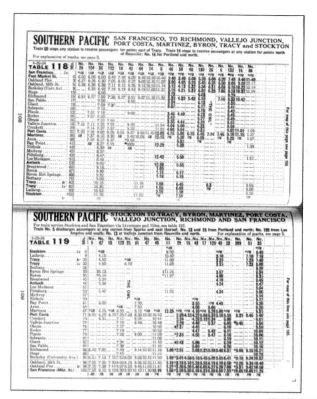

According to the Peck-Judah Bluebook of June 1924, a train commuter could catch the train ferry in San Francisco after work at 6:00 p.m. and arrive at Byron Hot Springs at 8:30 p.m. The return trip the next morning left at 5:13 a.m. and arrived at the Ferry Building at 7:50 a.m.

Train prices were reasonable to Byron Hot Springs from both Los Angeles and San Francisco. One-way fares from San Francisco were $2.50 and only $15 from Los Angeles. Compare those prices with a one-way Bay Area Rapid Transit (BART) ticket from Brentwood to San Francisco today.

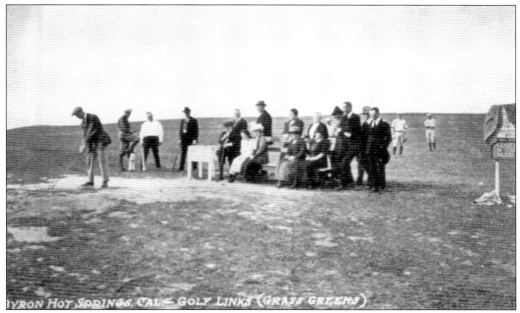

Golf became an early 20th-century craze. Hotel Del Monte had the first official golf links in California. Byron Hot Springs was close behind. In the early years, one could design a nine-hole course in the morning and open the course for play in the afternoon. Here are the refurbished golf links at Byron Hot Springs in 1922. Members of the San Francisco Seals baseball team stand in the background.

Water hazards on the golf course have new meaning when playing the Byron Hot Springs golf links. Note the path allowing visitors to walk to the various mineral springs high and dry from the alkali marsh. Early golf links like St. Andrews, Scotland, relied on natural hazards. Only tees and greens are lawn and manicured.

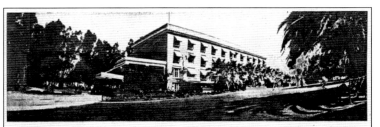

Golf continued to provide a draw to the springs as this *Byron Times* Twelfth Development Edition advertisement from the 1930–1931 proclaims. Miniature golf was a new fad. The original, full-size, 50-acre nine-hole golf links was quickly doubled to 18 holes. It is the same acreage now but plays with twice the number of holes. That makes the course "miniature."

Baseball had its day at the springs during the 1920s. The San Francisco Seals sent their pitching staff for a one-week pre-training camp before the entire team arrived at the Hotel del Monte, Monterey, for official spring training. "Lefty" O'Doul attributed his phenomenal ability to pitch nine innings to the restorative qualities of the hot sulphur mud baths at Byron.

There is a lot to do in eastern Contra Costa County. Half the fun is just driving there. This 1930s postcard shows many of the reasons why people visit the delta today. The fishing is great, the swimming is refreshing, the accommodations are first class, boating is fun, and wonderful picnic opportunities abound after a stop at a favorite Brentwood fruit stand.

High wheel bicycles were popular in the 1890s and provide a sentimental backdrop for snapshots. Margaret Baralli of Petaluma poses for the photographer while on a visit to the springs in the 1920s. The private cottages are in the background behind the row of eucalyptus trees.

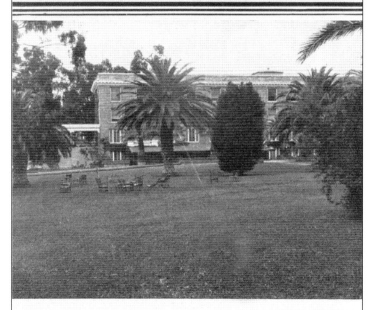

Some of the last operators of the resort before the outbreak of World War II were visionaries in their emphasis on physical fitness as a marketing tool. Unfortunately, they missed the financial success of present-day fitness resorts by 60 years. All the modern physical elements of a destination fitness resort were in place. All that was needed for success was a marketing plan, the end of the Depression, and an end to the looming crisis in Europe.

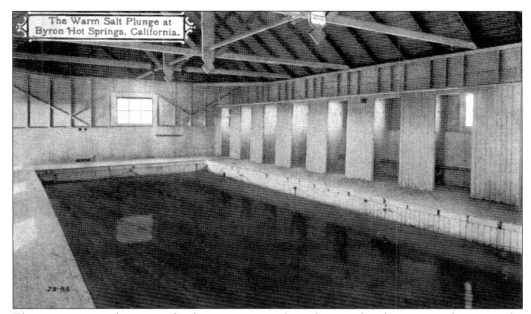

The swimming pool continued to be an attraction. In early resort brochures, it was known as the "Baths of Beauty" with effervescent water fabled "to render the bather soft and smooth: roughness, harshness, even wrinkles disappear before the soothing touch of this bubbling water." In reality, it was the only swimming pool within 20 miles. Local children swam for free.

The semitropical gardens planted by Lewis Mead in 1885 took on a more desert-like appearance in the early 1940s. Mead filled in the salt basin in front of the original wooden First Hotel with 10 to 12 feet of good topsoil from the delta. Water was abundant from the over 50 springs on the property.

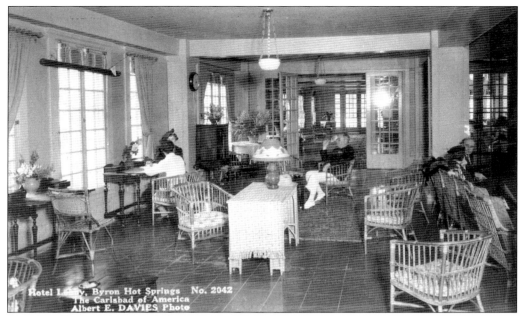

Comfortable furnishing and pleasant company surrounded hotel guests. This photograph, taken in the lounge of the brick Third Hotel, expresses the modern décor of the resort. Note the woman writing a postcard to home at the writing desk on the left. The dining room is visible just to the back and right of the visitors sitting on the couch.

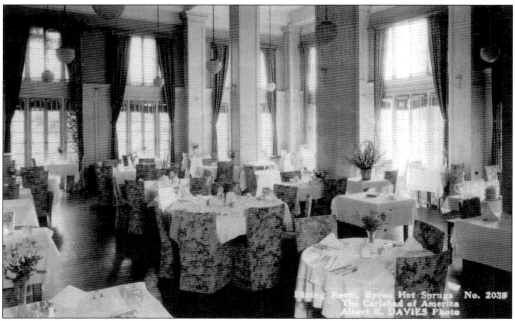

An attractive dining experience awaited hotel guests and day visitors. Good food was always the hallmark of the hotel restaurant. Produce came daily by train from green grocer markets in San Francisco. Local farmers provided eggs, butter, and seasonal fruits and vegetables. Many a local farmer thanked the resort management for actual hard cash payment during the Depression.

Six

"Camp Tracy"— Interrogation Center

As the first prisoners of World War II arrived in the United States in 1942, the War Department established two interrogation centers, one on each coast. The army considered these military bases to be temporary detention centers for the specific purpose of interrogating certain prisoners of war. They were subsequently transported to prison camps elsewhere in the nation for the duration of the war. All camps were top secret for fear of German and Japanese retaliation upon American soldiers held abroad. The military created Fort Hunt at Alexandria, Virginia, and the other interrogation center at Byron Hot Springs. Ten thousand dollars were allocated to acquire and prepare Camp Tracy for receiving prisoners.

The camp was comprised of two areas. The portion of the reservation inside the inner fence enclosure was the interrogation center, operated by the chief of military intelligence. The outer area was reserved for barracks, mess halls, and recreation. The interrogation center was divided into two sections: the Japanese section and the German section. During 1944, approximately 921 Japanese prisoners and 645 German prisoners were questioned. The maximum number of prisoners on hand at any one time did not exceed 51. In each section, there are maps drawn from the information acquired from interrogations, decoding rooms, and general prisoner quarters from which information is gathered through hidden microphones. It is reported that all buildings used by the prisoners were electronically bugged. The information gathered in this manner at Camp Tracy may well have decided the outcome of some of the critical campaigns of the war.

While the army leased Byron Hot Springs, the hotel and outbuildings were remodeled, a garage was built, and several miles of underground sewer lines were laid. Other improvements were also made by order from the War Department. Camp Tracy was declared surplus property after the war and the lease partially deactivated around August 1, 1945. The camp was ordered closed by September 1, 1945. Equipment and improvements were needed at other installations and were removed from Camp Tracy before the army released the property. The property then reverted to its owners and was once again known as Byron Hot Springs.

The only non-government source of Byron Hot Springs images between 1945 and 1950 is private soldier Ernest "Blackie" Black, seen here posing in front of the camp pickup truck. Part of Private Black's responsibilities were to travel to the Tracy Depot for mail and supplies. Camp Tracy was a top-secret military interrogation center during World War II. As such, any photographs taken of the facility libeled the offender to court marshal.

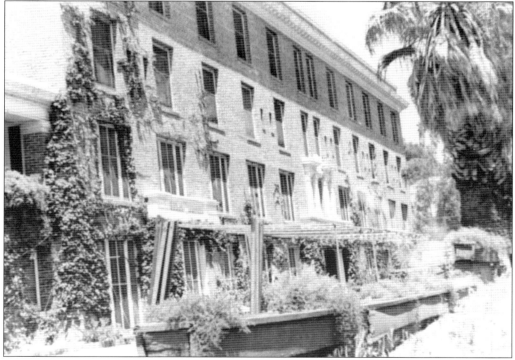

The once-glamorous brick Third Hotel was reduced to a prison during the U.S. Army stay. Note how all the windows in the building are blackened with paint. Prisoners could not see out, but more importantly, no lights could be seen at night to reveal the camp's location. Blackened windows were common in both military and civilian locations to ward off potential air raids.

SECRET

MEMORANDUM for Chief, Aliens Division

SUBJECT: Inspection of "Byron Hot Springs"

Inspection.
On April 19, 1942, Major R. W. Robb, Office of the Assistant Chief of Staff, G-2, Western Defense Command, and Captain Earl L. Edwards, Office of the Provost Marshall General, inspected a health resort near San Francisco, California, known as "Byron Hot Springs", for possible use as an interrogation center. The party left the Presidio of San Francisco at 8:30 a.m. and returned at 3:00 p.m. It was driven in an Army car.

Location of Property.
"Byron Hot Springs" is fifty four miles east of San Francisco. It is two miles from the town of Byron and is in Contra-Costa County. It is on the road leading from California State Route #50 to the town of Byron.

Owner.
The springs were first discovered in 1868 by a Mr. Meade, the first husband of Mrs. Mae Reed, the present owner of the property. Mr. Meade observed Indians taking baths in the sulfur springs and conceived the idea of establishing a health resort on the property. Mr. Reed, the present husband of the owner, was the architect for the buildings. Mr. and Mrs. Reed now live on the property.

General description
The property is completely hidden from any public road or any house on other land. It is entered by way of a private macadam road that is in satisfactory condition. This road runs to all the principal buildings.

There are 210 acres in the property. The terrain is slightly rolling around the buildings. Otherwise it is flat. However, some of the ground around the springs is low and is practically marsh land.

The National Archives produce some interesting documents about activities at Byron Hot Springs during the period of 1942 to 1945. It is learned third hand the inspiration for creating a spa and health resort at the salt springs from interviews with Lewis Mead's widow. The recapitulation of the discovery of the springs reads as if from one of Mead's own marketing brochures as relayed by his adoring widow, Mae.

The infrequently photographed back of the brick Third Hotel received the same treatment as the front of the building. Support staff waits with vehicles to transport passengers and freight. Prisoners were transported to the camp at night via ferry and bus from Angel Island, their initial arrival point in San Francisco Bay. They were ferried from the island to Berkeley and then driven to Byron. Bus windows were blackened to conceal the destination from the prisoners.

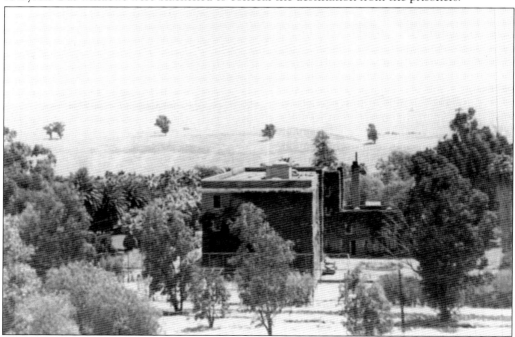

Local residents will recognize Byron Hot Springs Resort in this image taken from the water tower hill located on the north side of the property. The view is to the south toward what is now the Byron Airport and Brushy Peak. The fence on the near side of the hotel surrounds a tennis court. A nine-hole golf course was once located just before the far tree line.

> The entire place is surrounded by what is known as the Crocker property, a wheat farm. It is reported that its closest buildings are over a mile away from "Byron Hot Springs".
>
> Large palm trees surround the main buildings. There is also a five acre Palm Park. Cement walks run between all buildings.
>
> On the property is a 250,000 gallon reservoir. Four large tanks of about 30,000 gallons each are used for filtering. Connected with the reservoir are pressure tanks with a capacity of 60,000 gallons. The place uses this water and its own pumps during the winter when water is plentiful. During the dry season, it uses water supplied by the Byron Bethany Irrigation Ditch Co. There may be some difficulty with the private system since the operators of the resort are hauling drinking water from the nearby town of Byron. However, the owner says the system merely needs to be adjusted.
>
> Hotel.
> The main building is constructed by brick. There is nothing distinctive or attractive about its appearance. It is merely a four-story box-like structure with various wings.
>
> The hotel was erected in 1915. It has been maintained in excellent condition throughout. At the time of the inspection there were many guests present. Their activities, and those of the help, gave the impression of a well built and operating plant.
>
> Outside the hotel on one side is a large bush terrace. On the other side is a single concrete tennis court. A circle drive is in front.
>
> The inside of the building is arranged as a hotel. It has fifty bedrooms, each with a toilet and wash basin and each with an outside exposure. The rooms are in excellent condition. They are neat and well furnished. Their size usually is 11 by 12 feet. Also there is an elevator now working.
>
> Room arrangement is as follows:
>
> <u>Ground floor</u>
>
> 5 bedrooms
> Game room 30' x 50'

Here is a military assessment of resort assets property in a new perspective. The 250,000-gallon reservoir referred to is the tank built by Mead as fire protection after the Moorish-style Second Hotel was destroyed by fire. It was fed by Risdon-manufactured pumps and pipes located on the bank of Old River. The water company was incorporated as the Associated Pipe Company and was the predecessor to the Byron Bethany Irrigation District.

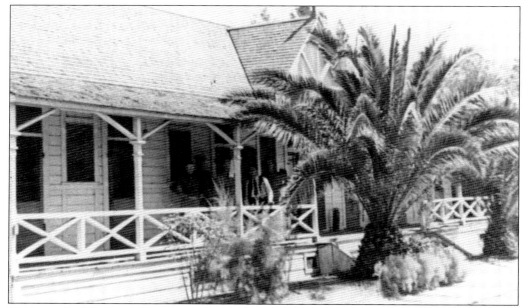

Uniformed soldiers stand on the porch of what was the infirmary or medical office during the resort's days as a health sanitarium. The U.S. Army used the same building as an infirmary for both soldiers and prisoners. One man wears civilian clothes but it is not known whether he is part of the intelligence community, a physician, or something else.

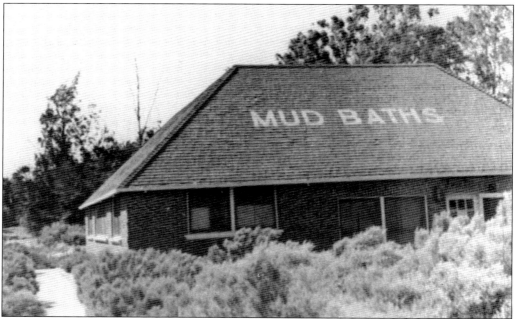

One of the attractions of Byron Hot Springs as a candidate for a West Coast interrogation camp was its springs. The military knew that Europeans enjoyed spas, mineral bath resorts, and health sanitariums. The Byron Hot Springs Resort's reputation as the American equivalent of the resort in Carlsbad, Germany, would prove useful for "softening up" German prisoners to get them to reveal information helpful to the war effort.

```
2 rooms full of stalls and mineral baths 30' x 40'
Employees toilet
Boiler room (Oil burner, hot water heat)
Refrigeration room (General Electric) 15' x 15'
3 Store rooms
Stair to kitchen
2 men's lavatories
Barber shop 12' x 15'
```

The ground floor is level with the surrounding ground.

<u>First floor</u>

```
Lounge 30' x 40'
Dining room 40' x 40'
Pantry
Kitchen 30' x 40'
Employees' dining room 20' x 20'
8 Bedrooms
```

the lounge and the dining room are two stories high. At the level of the second floor, there is a balcony around them. A formal main stair leads from the lounge. In the kitchen are three General Electric Refrigerators and a large oil rotary stove.

<u>Second floor</u>.
 14 Bedrooms

<u>Third floor</u>.
 23 Bedrooms

<u>Other Buildings</u>.
 The owner states that fifty eight persons can be accommodated in other buildings on the place. However, with proper arrangement it is possible to house many more within them.

There are two dormitories. Each contains twenty rooms (8' x 10'), a set of showers and bathroom. Every room is equipped with an electric heater. These dormitories are frame. Although they were constructed probably as cheaply as possible, they are adequate for barracks. There

The captain was concise in his description of the hotel and other buildings. One can appreciate his professional military reinterpretation of the beautiful, brick Third Hotel—envisioned by architect Reid as a miniature Fairmont Hotel—as merely a box-like, four-story building perfectly adaptable as a prison. Note the use of the word "lounge" instead of restaurant and bar.

Bernhard Reyak, 21, of the U-615

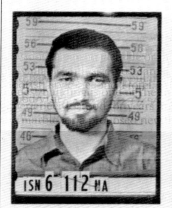 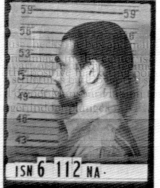

Otto Stengel, 26, of the U-352

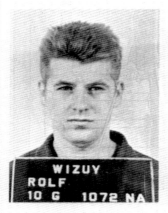 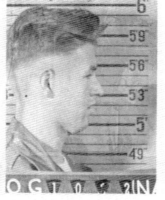

Rolf Wizuy, 23, of the U-615

The faces of seven of the hundreds of men interrogated at Camp Tracy are known as the Papago Park Seven. These men were removed and taken prisoner from a captured German U-boat off North Africa in 1944. They were taken initially to the prisoner-of-war camp located at Papago Park, Arizona.

The Papago Park Seven were sent to Camp Tracy as part of an investigation into the hanging death of their U-boat shipmate, Werner Drechsler. Drechsler was believed to be an informant and therefore a traitor to Hitler and the Nazi regime. Drechsler's body was found in the camp shower and suspects were detained. Local investigative efforts proved fruitless. The seven likely conspirators were sent to Camp Tracy for further questioning.

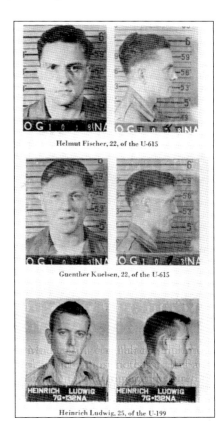

Helmut Fischer, 22, of the U-615

Guenther Kuelsen, 22, of the U-615

The Fort Leavenworth investigating committee accompanied the suspects to Camp Tracy in May 1944. A month-long investigation caused pieces of the execution of believed Nazi traitor Drechsler to surface. The findings of the board confirmed Drechsler's death by strangulation and recommended that the prisoners of war be charged with and tried for the willful and premeditated murder. Fritz Franke was the seventh of the Papago Park conspirators.

Heinrich Ludwig, 25, of the U-199

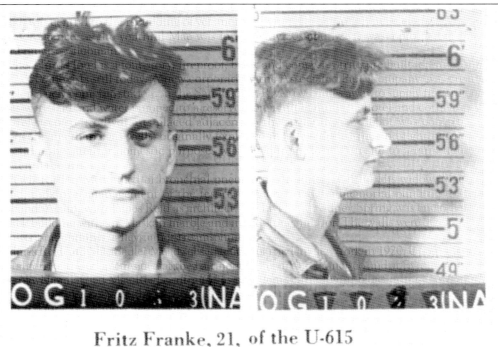

Fritz Franke, 21, of the U-615

is also another frame building that provides the barest minimum in living conditions. It can sleep ten.

In addition, the property contains two frame cottages having eight rooms and a bath, and two frame cottages having three rooms and a bath each. Also, there are seven one-room cottages, each containing a wash stand. These cottages could provide ample space for officers quarters, an infirmary, canteen, and other required facilities.

Mrs. Reed's home is on the property near the hotel. It is a large white frame house of a suburban style of four decades ago. It contain a living room, dining room, kitchen, four bedrooms, and three baths. Its heat is supplied from the hotel. The house is in good condition. It would be suitable for the home of the Post Commandant.

Also on the property is a farmer's house. This has six rooms and a bath but it is in second-rate condition.

Other buildings are as follows:
 A nine-car automobile shed
 A frame shed (40' x 80') covering a sulfur pool
 a brick bath house (40' x 80') divided into
massaging and dressing stalls, and mud and sulfur baths.
 A brick memorial building (15' x 75') containing a sulfur spring in each end. One of these is 90° Fahrenheit and the other is near freezing.

<u>Suitability for Guarding</u>.
"Byron Hot Springs" is the most completely isolated of all the properties inspected. In the first place, there is no attractive scenery or business to draw travelers to the road that runs by the place. The area is almost desolate. It is assumed that the only persons who might come near the property are the few farmers nearby and the several dozen people who live in the town of Byron.

Secondly, there is a natural ridge that follows the boundary of the property. At every point, this boundary is on the far side of the ridge. Consequently, it is impossible to see any of the buildings from any place beyond.

The terrain is sufficiently level to provide good fencing lines and good fields of fire. Few, if any, trees would have to be removed.

"Mrs. Reed's [sic] home" is described as suburban, not the Queen Anne style it is recognized as today. This is the Mead Cottage, built by Lewis Mead for his first wife and now occupied by James and Mae Reid as their home. Mae Reid neglects to mention her other home, where she and Lewis lived and she and James now reside—the Fairmont Hotel on Nob Hill in San Francisco.

Cost.

Mrs. Reed is willing to give the property to the Army for the duration of the war and enter into a 99 year lease thereafter with an agreement to leave it to the Army by will upon her death. Her motives are patriotic and are prompted partly by the fact that her only son, an Army Officer in the Medical Corps, was killed during the last war. She is not willing to sell since she regards the property as a memorial to her first husband. As she says, "It would be like selling one of the family".

However, the property is now loaned on a 99-year term to a retired Navy doctor who is attempting to run it as a health resort. His patronage is not sufficient to establish the place on a paying basis. Neither is there any prospect of his business improving. Since he cannot keep up with the rent on the place, Mrs. Reed believes he will have to give it up in a short time. It is thought that he would be willing to give it up for a very reasonable sum. To that sum there would have to be added approximately $100,000 for remodeling and the installation of technical equipment.

Conclusions.

1. Col. John Heckerling, Assistant Chief of Staff, G-2, recommends the use of "Byron Hot Springs" as an interrogation center because of the luxury and popularity of various baths among the Japanese. He believes these would be most conductive to "softening up" Japanese prisoners of war.

2. The property is sufficiently near to San Francisco.

3. Sufficient existing construction is present and adaptable to use as an interrogation center.

4. Isolation and guarding features are outstanding.

5. The property can adapted to profound uses with a minimum expenditure of time.

6 There may be little or no cost to acquiring the property.

7. It is doubtful that the buildings or the land would have any salvage value after the war.

Mae Reid paints an interesting picture of her reasons to lease the resort to the military. They agreed on lease payments of $250 a year, a small amount for such a patriot. The only son referred to is in fact her stepson, Dr. Louis Durant Mead, who held a medical officer commission in World War I. His commission was revoked before reporting for active duty due to insanity, and he later died of "softening of the brain" in 1916.

```
        8. "Byron Hot Springs" is the best suited of all the properties
inspected.

Recommendation.
        That "Byron Hot Springs" be acquired for use as an interrogation
center immediately.
                                                   Captain Earl. L. Edwards.
```

DECLASSIFIED

Authority: NND74063
By: JCSL
NARA Date: 8/18/92

SECRET

Captain Edwards's superiors accepted his recommendation for acquisition. The lease was signed and proposed military conversion improvements began in a matter of months. Mae and James Reid relinquished their Mead Cottage home. They returned once the war was over, as the army had no further interest in the property. The Reids later remarked that the estimated $100,000 in property improvements made by the military was stripped, leaving an empty shell.

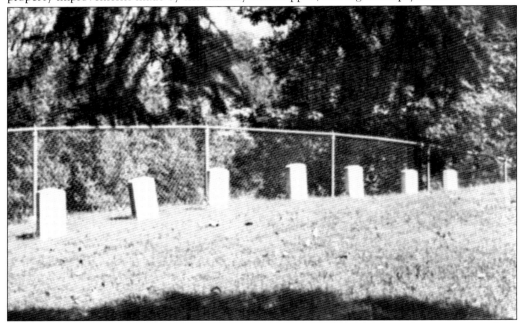

Seven POWs were transferred to separate prisoner-of-war hospitals and camps after their interrogation. They were reunited in Florence, Arizona, at a military court martial in July 1944. All were found guilty and sent to Fort Leavenworth in Kansas on August 24, 1945. They are buried there, against the far fence just west of the disciplinary barracks. The war in Europe had been over since May 8, 1945.

Seven

The Resort Sleeps

Early in 1946, ownership of Byron Hot Springs transferred from its original owners, the Mead family, to the Greek Orthodox Archdiocese of North and South America. The acquisition was the legacy of Athenagoras, then primate of this archdiocese. He renamed the property Mission St. Paul, envisioning it as the bishop's see, a spiritual retreat, and the center of Greek Orthodox church activity for the Western United States. Expectations were high for the parcel and its improvement as a retreat and mission. Regrettably, the full vision for the monastery was not realized, and the property was sold again in 1956.

The mission grounds sold to an East Bay consortium known as the Byron Hot Springs Corporation. In 1959, J. Branch Donelson acquired the property, but it returned to the Greek Orthodox church. In 1965, the property changed hands again, this time to a consortium of five people known collectively as Byron Resorts.

Many owners have held the title since that time. One of the most promising ownerships was that of Jon and Dixie Adams. The husband-and-wife team sought to improve the property, renovate the structures, restore the resort, and dredge a large lake. Perhaps the property's greatest notoriety was during ownership as the site of the Great 1890s International Bazaar held during the summer of 1972.

Opportunity for an extensive restoration and new glory came in 1978. The financial resources and desire to restore the historic resort were within new owner Mansour Hakimi's grasp. Regrettably, the Shah of Iran's regime fell shortly after his purchase of the springs. Cash needs prompted another sale and another buyer was found. Developer Ray Lehmkuhl Company of Walnut Creek acquired the property and the development dreams with it. Circumstances and illness plagued the project and the property sold at a trustee sale once more.

Since 1987, the historic resort and grounds have been effectively land banked by the Contra Costa County Planning Commission. The grounds lay unused and unoccupied except by groundskeepers. So far, none of the ambitious plans to return Byron Hot Springs to glory has materialized. Byron Hot Springs, like its 150-year history, awaits rediscovery.

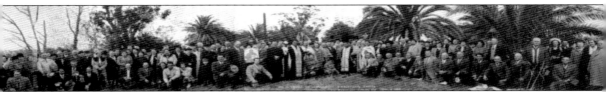

On Wednesday, December 8, 1948, Athenagoras I, the first United States citizen to hold the position of Grand Patriarch of the Greek Orthodox Church, assisted by members of the clergy, numerous dignitaries, and parishioners of the church, dedicated Byron Hot Springs property as Mission St. Paul. The church bought the hotel and 160 acres from Mae Mead Reid with cash collected from parishioners.

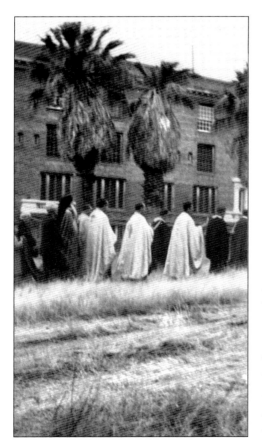

Clergy and parishioners walk by the hotel in procession. Note that the windows of the hotel are still blackened from the property's time as a military interrogation center. Physical improvements to the property began in 1948. The Liver and Kidney Springs building was rededicated as the Life-Giving Spring or Zothohou Peeyee, and an altar and religious icon were installed. Finally, a cemetery, "Memory Park," was consecrated near the western edge of the property.

Dixie Adams, seen here at the pottery wheel, joined equally in her husband's plans to renovate hot springs. She converted the firehouse into a pottery studio and encouraged tenants at the springs in hand weaving, organic farming, and other cottage crafts so popular in the late 1950s and 1960s.

IN OLD FIREHOUSE—Dixie Adams now does potting in the old firehouse at Byron Hot Springs. "It's a nice place for artists, I think," she says. "A very serene atmosphere."

WHERE THEY'LL LIVE — Jon Adams sits in an antique Roken barber chair in the old Mead mansion at Byron Hot Springs with 6-month old daughter, Love. Jon and his wife, Dixie, now live in the old Devonshire House, which they've restored, but they are fixing up the old Mead house and plan to move in.

Jon Adams, seen here with his daughter, made his reputation as the real estate sales manager for Tahoe NorthStar Resort at Lake Tahoe, California. He relocated to the Byron area and is credited with naming the residential home development now known as Discovery Bay. Jon sold his development rights to Discovery Bay and used the proceeds to acquire Byron Hot Springs in 1972.

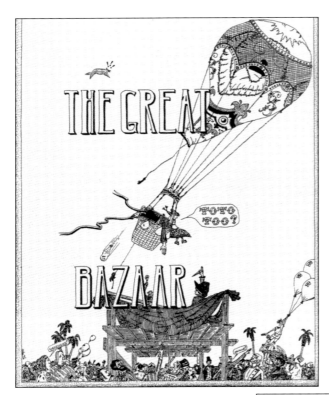

Perhaps Byron Hot Springs' greatest notoriety came during the summer of 1972 as the site of the Great 1890s International Bazaar. The bazaar was created by the Harbingers, who were best known for their creation of the Renaissance Faire first staged on Mount Tamalpias in 1969. Artisans and entertainers wore the original flying monkey costumes used in the movie *The Wizard of Oz*.

Advertising for the Great 1890s International Bazaar was extensive. The opportunity for a 1890s-themed event that embraced medieval anachronisms, alternative lifestyles, the modern Arts and Crafts movement, hippies, and all those on the "magic bus" was great. Half of the San Francisco counterculture was expected; then it rained. It was a cultural washout.

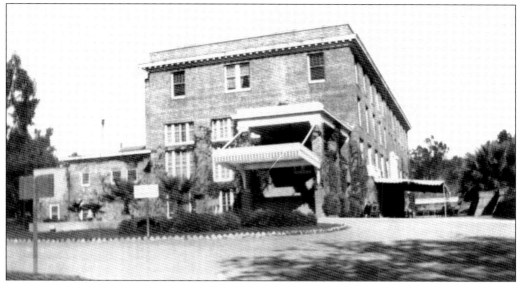

The opportunity for an extensive restoration of the property and return to glory came in 1978 with the resort's new owner, Mansour Hakimi. The financial resources and desire to restore the historic resort were within Hakimi's grasp. Regrettably, the Shah's regime fell in Iran shortly after his purchase of the springs; his assets were frozen and lost.

Vestiges of the original marsh, alkali pans, and natural mineral deposits are visible on the property. This photograph, taken from the present Byron Airport in midsummer, shows the brush, grass, and salt pans first observed by explorers. Coyotes, rabbits, squirrels, and occasional cattle still graze and lick salts from the ground. All the trees planted by Mead sit in the 10 feet of topsoil he imported from the delta.

FARMS / RANCHES / ACREAGE

CALIFORNIA CALIFORNIA

Historic
BYRON HOT SPRINGS
FOR SALE

- 212 Acres
- 10 Acre Lake, Landscaped Grounds
- Paved Roads, Water System with Hydrants
- 4 Story Brick Hotel
- Many Restored Buildings
- One Hour From S.F.

415-634-1200
Shown by Appointment Only

In keeping with a century of marketing, a Byron Hot Springs advertisement appears in the *Wall Street Journal* around 1975. Unfortunately, it was a "for sale" ad. No proprietor of Byron Hot Springs, since Lewis Mead, has found the magic necessary to create a going business concern.

This brass plaque set at the front gate of the springs is truly a sign of the times. It was a common belief in 1890s San Francisco (often attributed to Mark Twain) that "it takes a California gold mine to develop a Comstock Lode silver mine." The Risdon/Mead family owned an iron-manufacturing "gold mine" that they used to develop the Byron Hot Springs salt mine. Restoration may require a gold mine from the next prospective Byron Hot Springs developer.

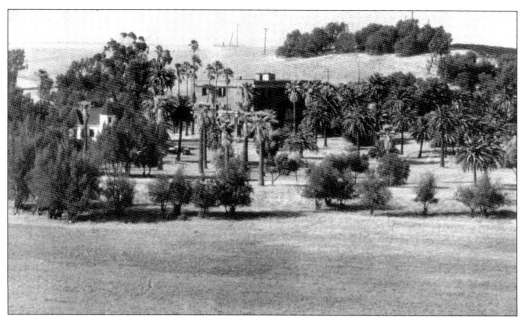

This is the Byron Hot Springs property as photographed from the southern hills. The outline of the Palm Court is still visible as is the brick Third Hotel. Most of the palm trees are over 135 years old. A palm tree can transpire over one gallon of water per hour. Those who claim that the springs have all dried or that water must be piped into the property need only look to the palms to learn otherwise.

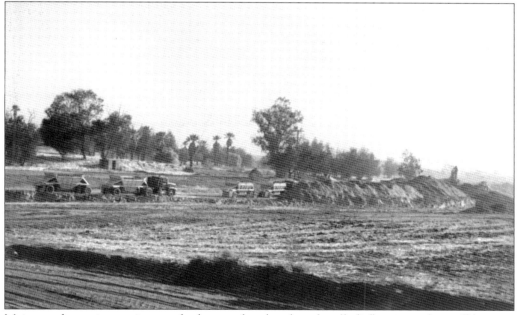

Major earth-moving equipment dredges sand and sculpts the alkali flats into what will become golf course fairways, sand traps, and water hazards. The once-proud Mead Memorial, salt plunge, and mud bath stood at this site. Excess sand is transported to provide a foundation base for a new Oakley elementary school.

Two members of East Bay Associates, David Fowler, left, and Robert Milano, review plans for a golf course at the proposed new Byron Hot Springs Resort. Their ambitious plans include equestrian facilities, tennis courts, bocce courts, an 18-hole golf course, a medi-spa, retail shops, a wedding chapel, and convention facilities. The entire facility will be self-contained and will be a showplace for "green" construction (see below).

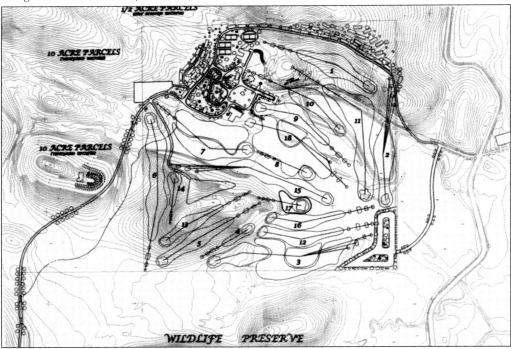

Initial plans for the new Byron Hot Springs Resort call for a championship 18-hole golf course, a spa building on the site that will be architecturally reminiscent of the Moorish-style Second Hotel structure, and a conference center inside the restored shell of the brick Third Hotel. All facilities and recreation will be environmentally friendly, using recycled resources wherever and whenever possible. Exclusively alternatively fueled transportation will be used on the property.

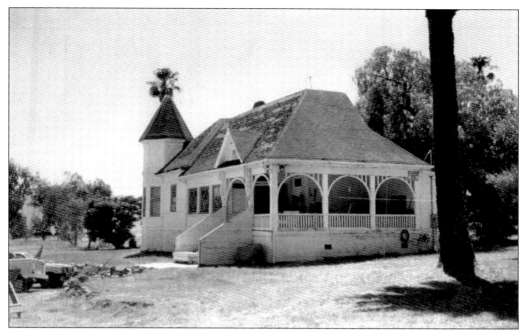

This is the Queen Anne–style Mead Cottage as it existed before vandals burned it to the ground in 2005. The building was occupied by resident groundskeepers as recently as 2003. The current owners had hoped to use it as headquarters office space for the planned golf links and spa resort.

Standing in front of the Mead Cottage in 2004 are descendants of the original owners, pictured with the author. Ward York (left) is the grandnephew of Mae Sadler Mead Reid. Robert Morton (right) is the great-grandson of Byron Hot Springs founder Lewis Mead.

The ground-floor entrance to the shade palms and lawn entertainment stands with doors open. No guests currently visit the hotel with the exception of vandals. The entire property is closed to the public. This photograph is one of the last postcards of Byron Hot Springs sold commercially.

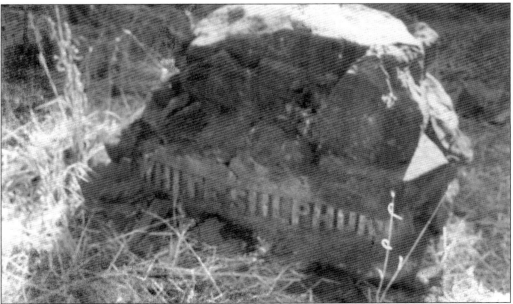

The remaining monument to the White Sulphur Springs is still in its original spot just outside the Palm Court. It rests in a depression of land surrounded by a few encircling original rocks. The lush bamboo is gone. The U.S. Army capped the springs over 60 years ago, as the smell offended the camp commander. The water is still there.

The Family Tree

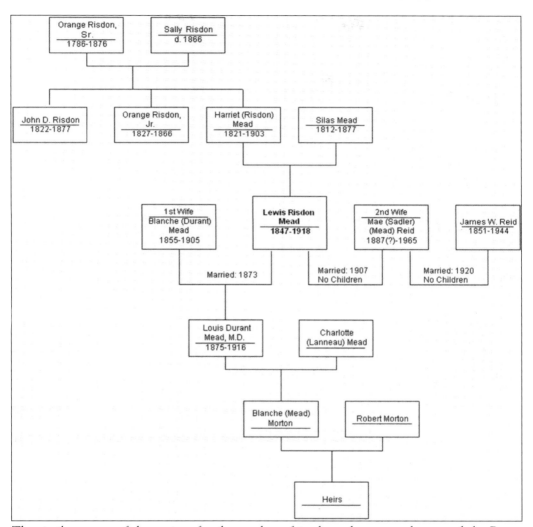

The similar names of the various family members, friends, and spouses who owned the Byron Hot Springs can be confusing. Lewis Risdon Mead is the main character around whom the resort saga revolves. This Risdon/Mead/Reid genealogy, tracing ownership of the springs, provides a visual overview of resort title.

Time Line

Before 1780	California Native Americans, Anglo fur traders, and Spanish explorers pass by the salt springs.
1847, September 7	Lewis Risdon Mead is born in Saline, Michigan.
1865	Lewis Risdon Mead arrives in California.
1865, October	Orange Risdon Jr. receives a land patent for 160 acres.
1868	Lewis Risdon Mead, nephew of Orange Risdon Jr., takes over exploitation and development of the Hot Springs site.
1868, April 27	Orange Risdon Jr. dies in San Luis Obispo and father, Orange Risdon Sr., inherits his estate. Lewis Mead appointed administrator of Orange Risdon Jr. estate.
1878	Arrival of San Pablo and Tulare Railroad. Town of Byron founded.
1878	The First Hotel, incorporating prior guest structures and annexes under one roof, opens as Mead's Hot Salt Springs.
1889, August 17	United States Post Office established at the springs.
1901, July 25	First Hotel destroyed by fire.
1902	Second Hotel opens for guests.
1905, December 26	Blanche Durant Mead, first wife of Lewis Risdon Mead, dies.
1907, June 20	Lewis Risdon Mead marries his second wife, Mae Sadler of Alameda.
1912, July 12, 5:00 a.m.	Second Hotel burns.
1914, July	Third Hotel opens.
1916, June 13	Dr. Louis Durant Mead, only son of the founder, dies.
1918, June 13	Lewis Mead dies of bronchial pneumonia.
1919	Property leased to San Francisco restauranteur John Tait.
1920	Mae (Sadler) Mead marries James Reid.
1943, January	Byron Hot Springs becomes "Camp Tracy"—a U.S. Army Interrogation Center for German and Japanese prisoners of World War II.
1948, December	Greek Orthodox Church purchases the springs and property and consecrates Mission St. Paul.
1950s	Contra Costa County considers purchasing the resort and using it as a polio therapy center for the county. Plans never realized.
1950	California Public Utilities Commission approves having Byron Hot Springs Station (class D station) dropped from Southern Pacific Railroad Schedule and timetables.
1956	Newly formed Byron Hot Springs Corporation announces plans for hot springs.
1965	Mae Sadler (Mead) Reid dies in San Francisco.
1972	Jon and Dixie Adams purchase the resort with plans to restore it to its original splendor and stage the Great 1890s International Bazaar.
1978, January	Mansour Hakimi, an Iranian millionaire, buys the springs property from Jon Adams for $650,000.
1988	The property is acquired by the Ray Lehmkuhl Company, Walnut Creek; Craig Lehmkuhl, Associate.
1989	Property acquired by East Bay Associates, LLC.
2006	Byron Hot Springs awaits the future.

BIBLIOGRAPHY

Anderson, Winslow M.D. *Mineral Springs and Health Resorts of California*. San Francisco, CA: the Bancroft Company, 1892.

History Channel, The. *Last Mass Execution*. Video Documentary, Cat no. AAE-40207. A&E Television Networks, 1998.

Klein, John C. "Where Water is Life." *Sunset: A Magazine of the Border*. Volume 10 Issue 2, December 1902. p. 155–158.

National Archives Trust Fund, Washington, D.C.

Sheppard, Steven. *A Matter of Last Resort: the Story of the Byron Hot Springs*. Unpublished manuscript, 1998.

Whittingham, Richard. *Martial Justice: the Last Mass Execution in the United States*. Chicago, IL: Henry Regnery Company, 1971.

Ocean Wireless News. Volume X number 5. Marconi Publishing Company. San Francisco, CA. p. 21.

ACROSS AMERICA, PEOPLE ARE DISCOVERING
SOMETHING WONDERFUL. THEIR HERITAGE.

Arcadia Publishing is the leading local history publisher in the United States. With more than 3,000 titles in print and hundreds of new titles released every year, Arcadia has extensive specialized experience chronicling the history of communities and celebrating America's hidden stories, bringing to life the people, places, and events from the past. To discover the history of other communities across the nation, please visit:

www.arcadiapublishing.com

Customized search tools allow you to find regional history books about the town where you grew up, the cities where your friends and family live, the town where your parents met, or even that retirement spot you've been dreaming about.